OFFICE FURNITURE

FURNITURE

TWENTIETH-CENTURY DESIGN

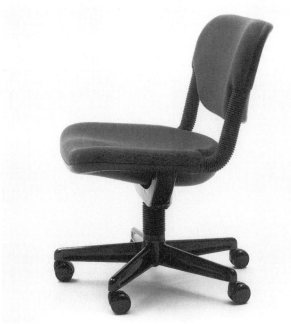

Lance Knobel

E.P. DUTTON New York

First published, 1987, in the United States
by E.P. Dutton

Published in the United States by E.P.
Dutton, a division of New American
Library, 2 Park Avenue, New York, N.Y.
10016.

Library of Congress Catalog Card Number:
86–73138

ISBN: 0–525–24537–5 (Cloth)
ISBN: 0–525–48300–4 (DP)

OBE

10 9 8 7 6 5 4 3 2 1
First Edition

Designed by Richard Crawford
Typeset by TJB Photosetting Ltd, South
Witham, Lincolnshire, England.
Produced in Great Britain.

*Overleaf: Ambasz and Piretti's 'Vertebra' chair for Castelli marked a turning
point in office chair design.*

CONTENTS

INTRODUCTION

THE history of furniture design has been well documented in numerous books and articles. But with few exceptions, attention has been focussed on furniture for the home. The office, where a large proportion of the developed world spends a third of their life, has been neglected by the historians. And to some extent, so recent has the differentiation of office furniture from domestic furniture been, that the seemingly disproportionate attention the home has received is understandable.

Office furniture has a history that barely extends back a century. But in the last hundred years the development of distinct designs for the office has developed rapidly. And as organizations and the technology they use have become increasingly sophisticated, so has the furniture used in the workplace had to keep pace. But the technical requirements of office furniture are but one part of their development. The office environment, and the furniture used within it, has continually been a key element in determining the relationship between an organization and its people.

Furniture in the office is usually a visible sign of hierarchy and status. Curiously, too, the most advanced furniture is frequently the furniture associated with the bottom rungs of an organization's hierarchy: the typists, clerks and computer operators. Executive furniture, for the most part, has changed remarkably little in a century. For this reason, this book concentrates on mass production furniture rather than special, one-off designs intended for the executive suite of a forward-thinking chairman or president.

In such a poorly researched field, this book is inevitably only an overview. But it outlines a number of subjects that could well prove amenable to far more detailed research. As the design historians direct their attention to office design, as key manufacturer's archives are explored, and as the detailed genesis of individual pieces of true greatness are revealed, a far greater understanding should develop of one of the major phenomena of modern times, the development of the office.

Many people were helpful in piloting me through the often uncharted waters of the history of office furniture. Although discussions with them were instrumental in developing my ideas and knowledge, any errors or misinterpretations are wholly my own. Particular thanks are due to Frank Duffy, John Worthington, Rodney Cooper, Terry Trickett, my colleagues on *Designers' Journal* and numerous other designers and furniture manufacturers.

Florence's Uffizi, designed in 1560–1574 by Giorgio Vasari, was probably the first distinct office building. With individual rooms ranged off a long corridor, its plan is little different from many modern office buildings.

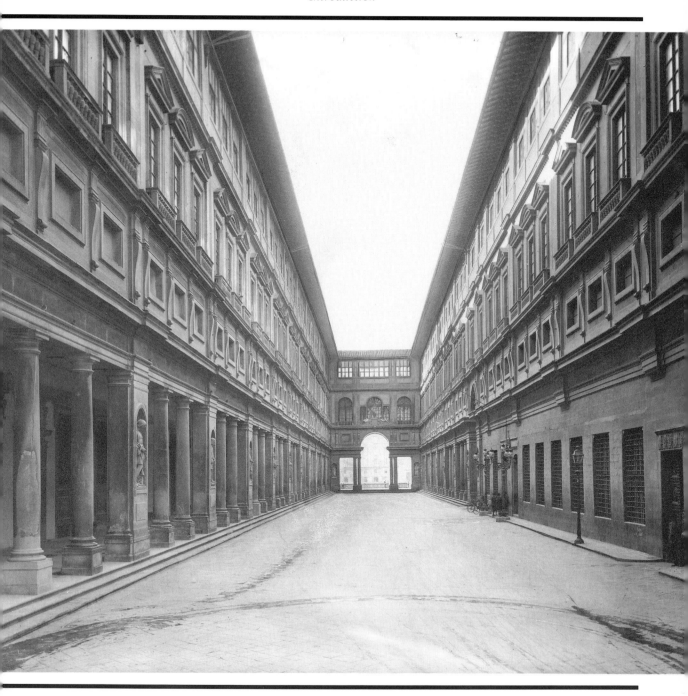

ORIGINS OF THE OFFICE

THE office building as a distinct building type dates back to the Renaissance. Nikolaus Pevsner, in his *A history of building types*, cites Giorgio Vasari's Uffizi, Florence, of 1560–74 as one of the first distinct office buildings. As visitors to the Uffizi Gallery today can see, the pattern of the building is familiar with its individual rooms ranged off a long corridor (though the space standards for the Medici's administrative centre are far grander than any that could be envisioned today). But for centuries following the Renaissance, the dominant type of office building was still one that contained residential accommodation as well. Even those buildings that were only offices took as their models domestic buildings.

Given this background, it is not surprising that office furniture was little different from domestic furniture. The gentleman's study provided the model for the office: a desk, the larger the better, with a comfortable chair was the only essential element of the office.

But the Industrial Revolution created a more modern concept for the office: the increasing complexities of industry spawned ever-increasing amounts of paperwork as well as parallel support services, such as lawyers, bankers, transportation and communication. Pevsner cites the

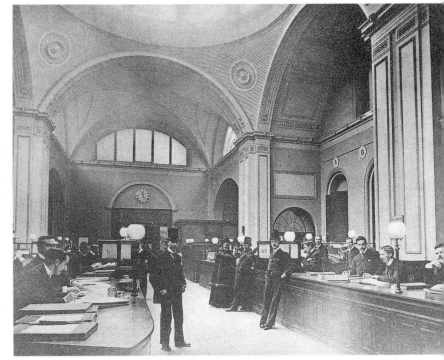

Among the grandest of the 19th-century offices was John Soane's Bank of England. The huge domed spaces of the Consol Office housed orderly rows of clerks at long desks poring over ledgers.

The gentleman's study provided a model for the office: fireplace, mantelpiece, wood panelling, solid, important desk.

modern office building as originating in 1819, with Robert Abraham's County Fire Office, Regent Street, London. But the most interesting development came in the 1820s and '30s when speculative office developments were created in London. According to Edward l'Anson, who lectured to the Royal Institution of British Architects in 1864, "*The first building which I remember to have been erected for that special purpose* [letting out separate floors for offices] *was a stack of office buildings in Clement's Lane at the end nearest to Lombard Street.*" New York followed the London trend some years later, but in all but the grandest commercial centres, office buildings remained converted dwellings.

The close relationship between office and domestic buildings continued into the 20th century. As the Italian critic Antonio D'Auria has observed, it is difficult to distinguish famous Viennese and London buildings around the turn of the century in

Even middle managers shared this aesthetic, with the important difference of smaller desks and smaller rooms.

terms of their function: Lutyens' housing in St James's Square and Great Peter Street, for example, could easily be interchanged with his offices for *Country Life* in Tavistock Street.

The office building, and office organizations, achieved their true differentiation in the United States at the end of the 19th century. Chicago architect Louis Sullivan was one of the first to codify the elements of the newest office building form, the skyscraper, in his 1896 article 'The tall office building artistically considered'. He described mechanical plant in the basement, shops and circulation space on the ground floor, above the base, an indefinite number of floors, each one equal to the next, with internal perimeters repeated in modular fashion to form individual workplaces, and a distinct attic, for further mechanical plant.

The rationalization of the office building proceeded concurrently with the rationalization of office work. Much of the thinking about methods of work was an extension from studies of factory work, especially those of Frederick Taylor. Taylor's 1880s research had convinced him that wasted movements and poorly designed equipment reduced the efficiency of factory workers. Taylor believed that an optimum method for each job existed, and it was the job of managers to set this method, and the time it took, as standard.

Taylorism extended to the design of the factory workplace. Henry Ford wrote about his own factory, "*We measure the space which the worker needs to perform a task with exactness. The worker must not be crowded: a loss of time would result from that. But if the worker and the machine occupy more space than necessary, another type of loss would be the result.*" It was a short step from applying this factory-orientated thinking to the office, particularly as machine-related tasks entered the workplace.

A series of inventions in the 19th century radically transformed the office. Samuel Morse's telegraph, first used in 1844, allowed offices to be separated from manufacturing facilities, and also, crucially, rapidly multiplied the amount of paper generated in a business. This flood of paper increased enormously as the typewriter, invented by Latham Sholes in 1866 and developed by Remington in 1868, became widely accepted. And Alexander Graham Bell's telephone, demonstrated in 1876, made the

Louis Sullivan began to define the characteristics of modern office buildings in a series of works in Chicago. His Auditorium Building, 1889, illustrates his clear distinction between the base, upper floors and attic of the structure.

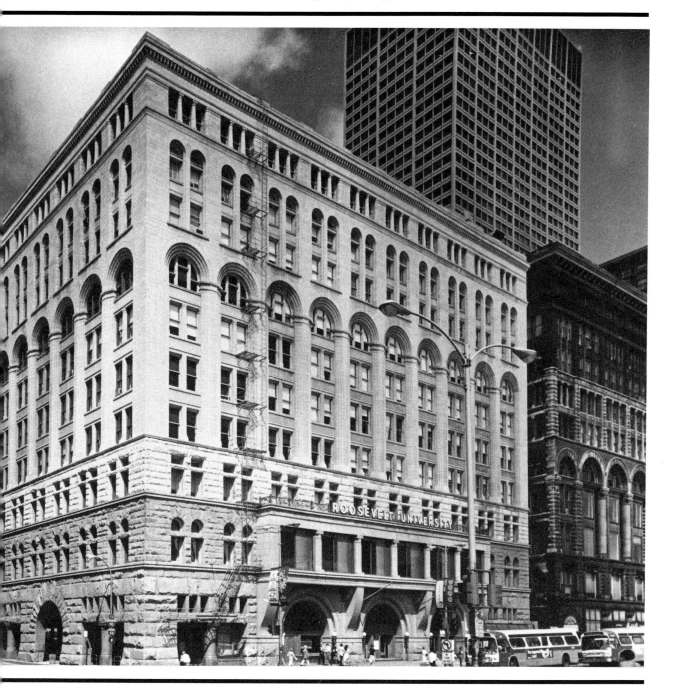

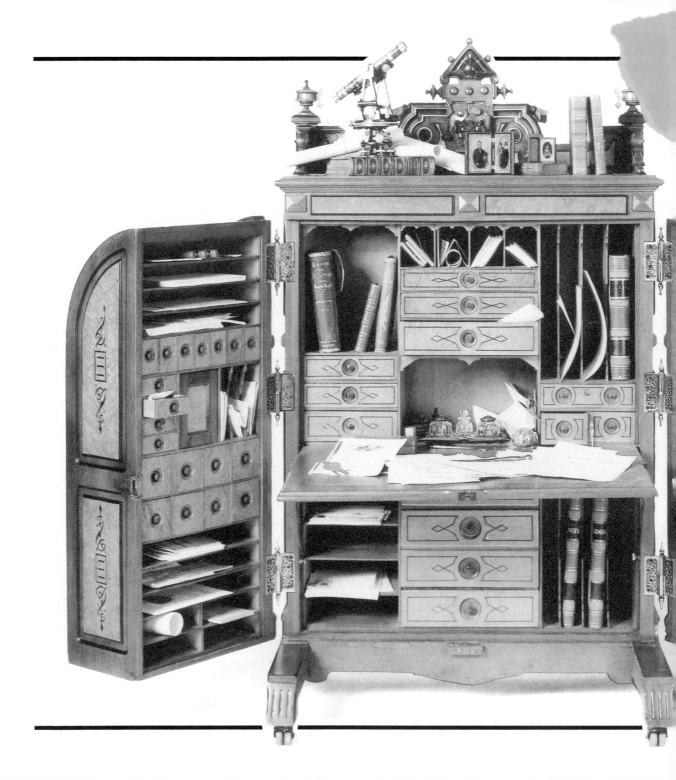

office, rather than the club, market or exchange, a centre for commercial communication.

The increasing complexity of commercial organizations, the proliferation of paper and the attempt to make the work of the growing army of office clerks more efficient, were all pressures that led to the development of furniture designed specifically for the office. For the most part, before the 19th century (and into the 20th for executives) the office, and hence office furniture, was merely an extension of the home. Tables, desks and chairs were an extension of the gentleman's study.

But new forms of organizations demanded new furniture. The desk that evolved was a visible demonstration of organizational efficiency: the roll-top (to hide mess when unoccupied), the numerous pigeon-holes and drawers to carefully file different papers above the worktop, and the set of pedestal drawers stretching down to the floor. The best examples of these desks reached a high art of craftsmanship. The 'Wooton Patent

The intricate Wooton Extra Grade Patent Secretary, 1874, enabled its users to pigeon-hole virtually every aspect of their work and life. Not surprisingly, it found favour with seriously important people like Presidents and corporate moguls.

Desk', popular with United States Presidents and corporate moguls in the 19th century, was a magnificent enclosure for all the minutiae accumulated by *important* people. Its very scale, likened to a grand pipe organ, dwarfed the user and announced the extreme importance of their tasks.

Historian Adrian Forty, in his book *Objects of Desire*, has carefully described the symbolism inherent in the other main form of the 19th-century desk, the high-backed, sloping clerk's desk.

"A clerk seated at a high-backed desk could see his work in front of him and a little to either side, but he could not see ahead beyond his desk, nor could anyone else see what he was doing without coming to look over his shoulder. Such a desk assumed that the clerk was responsible for its contents, and for his work; it represented a small private domain....Such a desk encapsulates the responsibility, trust and status given to some clerks."

The increasing complexity of commercial organizations eventually had a simplifying effect on their furniture. When clerks were responsible for a range of tasks, including filing, their desks needed to cope with demanding storage and organizational requirements. Adherents of Taylorism, however, believed that the reduction of work to simple, highly

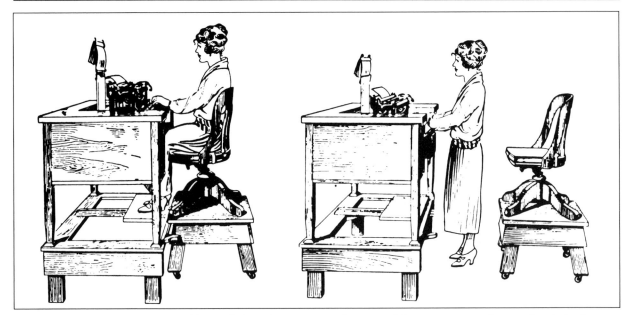

repetitive tasks would increase efficiency. So when companies had separate filing departments, and rows of filing cabinets and filing rooms, the elaborate pigeon-holes and drawers of a standard clerk's desk could be eliminated. A flat-top desk, for the managers, meant no possibility of papers being hidden or hoarded. A minimum of shallow drawers furthered this goal, and the banishment of the roll-top completed the procedure. Although the result was to lessen a clerk's privacy, and allow easy supervision of work, the justification of the new furniture was dressed in more appealing terms: pedestal bases hid dangerous germs and dust; roll-tops cut off healthy light and air.

The result is still prevalent in the

Almost obssesive specialization of furniture was widespread early in the century. This typist's workstation allows 'efficient' use, sitting or standing.

Simplification and standardization soon swamped the specialized furniture. Clean, efficient, germ-free environments were the claim by the manufacturers. Le Corbusier said of this furniture, 'This is cold and brutal, but it's right and true; the basis is there.'

Above: Typical late 19th-century desk, with a tamboured roll-top and high back giving clerks a modicum of privacy.

common, bargain-basement office supply shops littered in low-rent sites in all the major cities of the business world: a flat, table top, with a central drawer for an employee's personal effects and a number of suspended drawers on the sides for stationery and common reference material. The removal of the clerk's privacy and the depersonalization of his workplace was furthered in the early parts of the century by elaborate 'desk systems', standard methods for arranging papers on the desk and in its drawers.

Right: Recording and filing the work of complex organizations led to the development of special systems and the related furniture.

Les fiches " Ronéo "

As a result, managers could inspect desks to ensure that proper procedures were being followed. (Although such a rigidly controlled system seems fantastic today, many companies still operate rough equivalents, such as the common 'clean desk' policies which demand that no papers be left on desks at the end of the day.)

These widely disseminated ideas about proper modern, or 'scientific' office management almost invariably stopped at the entrance to the manager's office, however. The roll-top desk continued to be popular in the executive office, purportedly to protect confidential papers, and the efficiently small desk sizes prescribed for clerks were abandoned in favour of large, capacious desks. Whatever considerations of hygiene, efficiency and organization may have demanded, the priorities of status and hierarchy produced very different results.

Right: The 1904 offices of the Royal Insurance Company allowed clerks some hint of personal territory with the groupings of low-level partitions in a suitably grand space.

Below: Despite the claims of poor hygiene for clerks, the roll-top desk retained its appeal for executives. This solid Steelcase rolltop prospered into the 1920s.

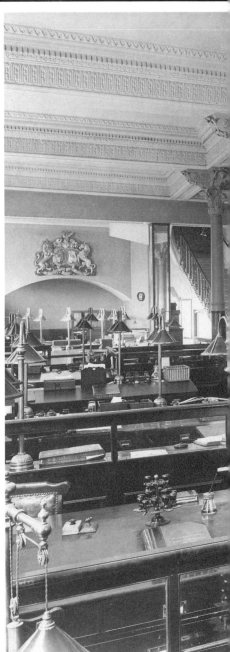

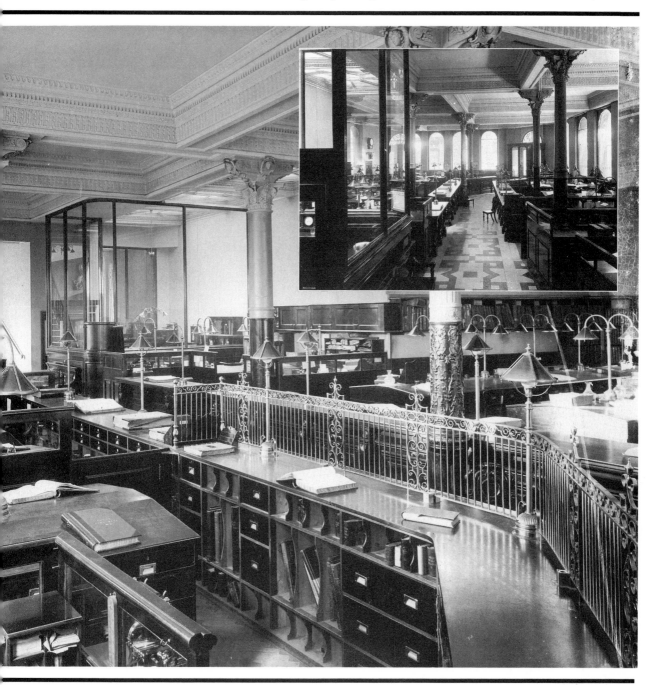

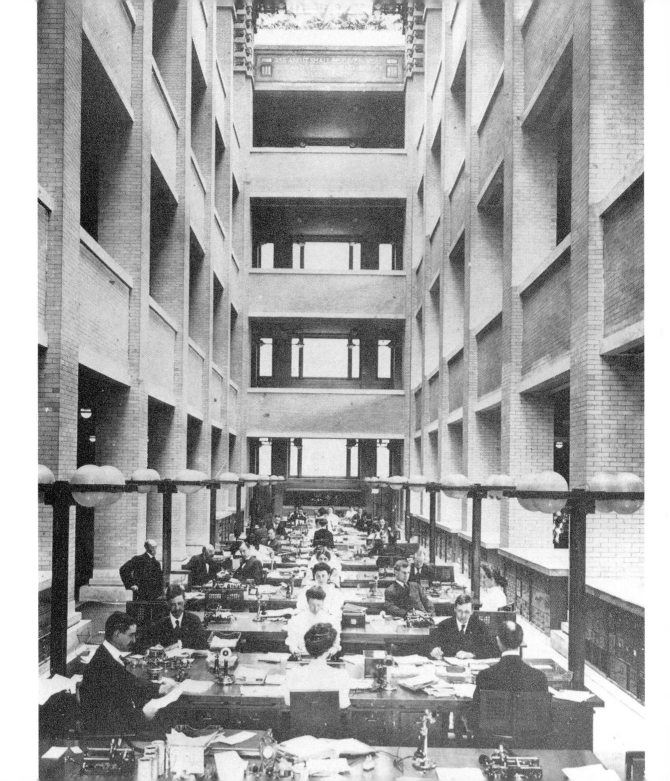

INTO THE 20TH CENTURY

ALTHOUGH changing office methods were rapidly altering the nature of office furniture, the most significant advance was for the 1904 Larkin building, in Buffalo, New York. Designed by Frank Lloyd Wright, who had already built a considerable reputation with his Prairie Style houses in the Midwest, the Larkin building was a pioneering work. The building was to provide accommodation for the 1800 secretaries, clerks and executives of a mail-order company, whose manufacturing facilities were on an adjoining site. In order to attract good employees (mostly female) to an industrial area of the city, the company specified a clean and comfortable building.

Left: The central skylit court of Frank Lloyd Wright's Larkin building, Buffalo, New York, 1904. The same date as the Royal Insurance Company but with a heightened perception of the nobility of work.

Below: For the patron of the Weiner Werkstätte, in 1904 Koloman Moser created a writing desk from ebony and macassar, with ivory motifs.

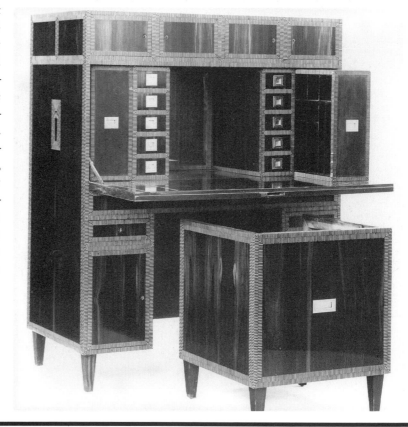

Wright's furniture for the Larkin building was the first metal office furniture. The strongly rectilinear lines of the desk and chair mimic the building's architecture (see illustration on page 34). A number of the great designers of the early part of the century created the odd, one-off piece of office furniture. Invariably for wealthy patrons, these works harked back to the gentleman's study, unlike Wright's forward-looking project for this building.

Wright was more than equal to the task. Among the innovations of the design was the air-conditioning system, the central skylit court (an architectural idea that was to become almost *de rigeuer* in American office buildings of the 1980s), and the furniture. Wright's was the first metal office furniture, and in terms of the careful relation between the different elements of the furniture, perhaps a precursor of what came to be called office systems.

The basic Larkin furniture was a single-pedestal, all-metal desk with a system of pigeon-holes for filing mounted at the rear of the worktop. The chair was fixed to the desk with a swivel mechanism. Loose armchairs used metal for the base, back and seat support, but were most significant because of the way in which their strongly rectilinear design mirrored the architecture of the building.

Not until Wright returned to the problems of office design in the '30s with his building for Johnson Wax was office furniture to aspire to such high levels of design. But there was one area where the attention of the

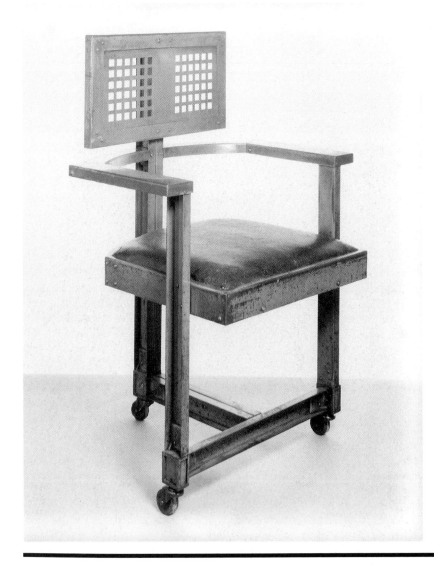

Right: Scottish architect Charles Rennie Mackintosh's simple oak armchair for the director's office at the Glasgow School of Art, 1904.

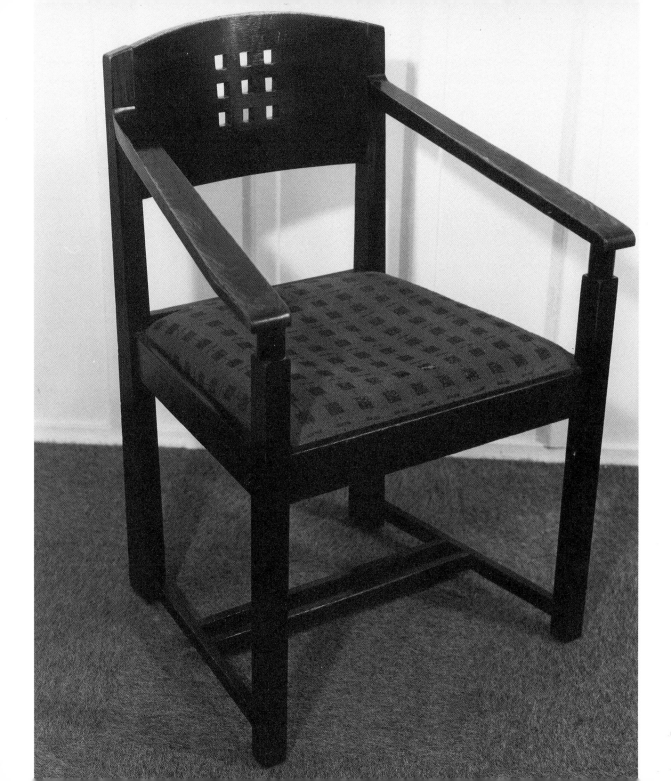

designers and the technical potential of the manufacturers produced true innovation, in the development of specialized chairs for office work.

Like so many aspects of office design, the invention of the true office chair dates to the 19th century. With the growth of offices and factories in the Industrial Revolution, came a parallel growth in the ranks of workers spending the major part of their day seated in front of papers or machines. The invention of the typewriter was probably the single most important event for the history of the office. (The great modern architect Le Corbusier, in fact, noted in his book *L'art decoratif d'aujourd'hui* that the typewriter led to the standardization of paper sizes, which in turn led to the standardization of file sizes, desk drawers, and ultimately of the entire furniture industry.) And it was the needs of typists that inspired the largest share of study into chair design. Typing, unlike writing, is a series of highly repetitive movements and requires a seat which keeps the body in a definite position. It is barely possible, in fact, to type for any length of time while sitting in a soft chair.

Peter Ten Eyck's 1853 swivel chair is the precursor of modern office chairs.

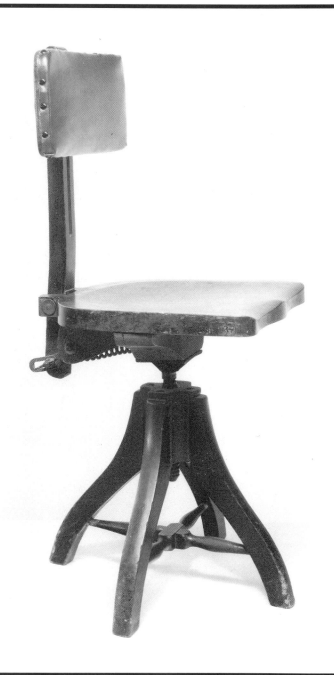

The classic office chair of the 19th century, and one that survived strongly into the 20th, was the American wood swivel chair. Supposedly invented by Peter Ten Eyck in 1853, the swivel chair was generally made of oak, with a Windsor chair-like seat, mounted on four legs with wheels. But the real innovation came in the junction between the seat and its base: here a mechanism allowed for the tilting back of the seat, for its swivelling and, frequently, for adjusting the height of the seat.

Ergonomics, the study of the interface between man and machine, is a relatively recent science. But many of the conclusions of ergonomists over the last 30 years can be seen in the mid-19th-century American swivel chair: height adjustment, to suit different workers; tilt for different kinds of work; swivel, to enable workers to reach papers without leaving their chair. Even the seat bottom of the classic American chair is shaped for maximum comfort, in a very similar way to modern chairs.

An early 20th-century chair exhibiting many of the characteristics of Ten Eyck's original: shaped seat, swivelling height adjustment and movable back.

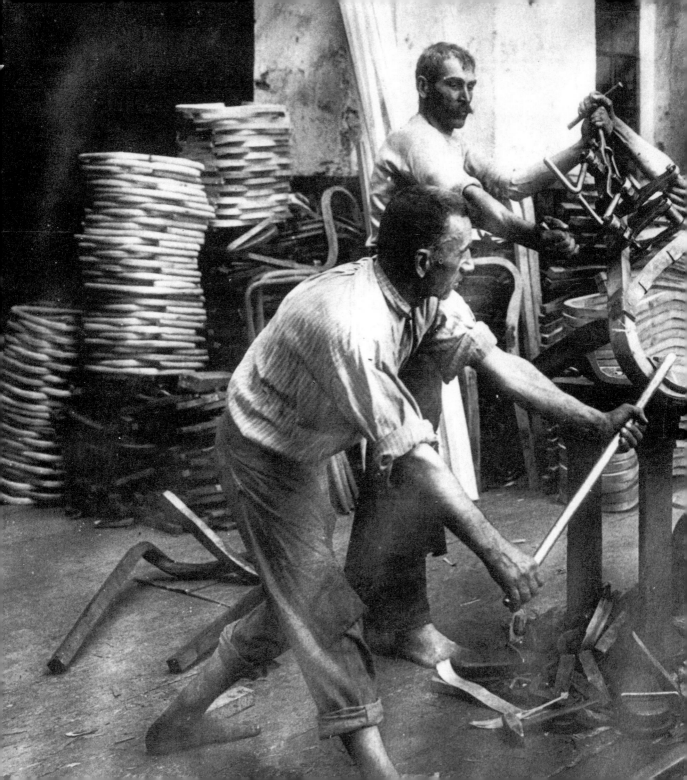

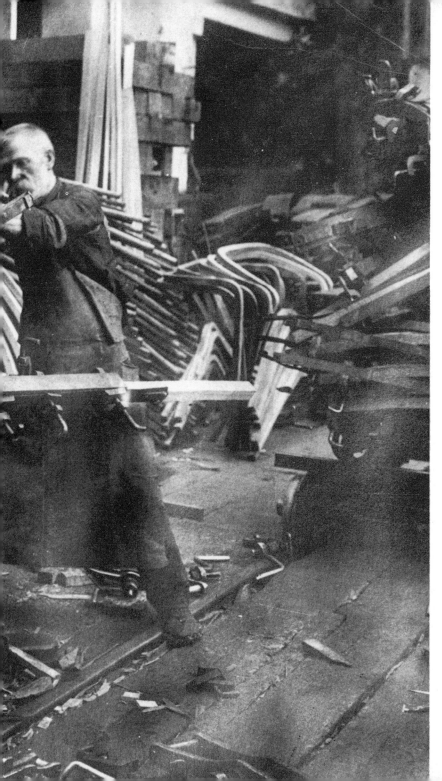

In the 1830s, Michael Thonet developed a new method for bending wood into curved shapes.

Variations of this basic chair became commonplace towards the turn of the century. Wright's 'Larkin' chair was the most distinguished example, and its basic elements were no different to those of Ten Eyck's 1853 design. But for all the visual distinction of the Wright chair, Ten Eyck's design, with its adjustable elements, was ergonomically more advanced.

While Ten Eyck and his followers were leaders in the technological development of the office chair, undoubtedly the most important furniture company at the turn of the century was Vienna-based Thonet. Michael Thonet started his career early in the 19th century as a traditional cabinetmaker. But around 1830, he began to experiment with bending wood into curved shapes, as an alternative to carving. Thonet developed a method using laminated veneers (thin strips of wood glued together). Compared with carving, Thonet's method proved less expensive, less labour-intensive and used less material, giving his products an enormous price advantage.

The early history of Thonet has

been well examined in a number of monographs. What is important where office furniture is concerned is the dominant position the company had achieved by the turn of the century. Thonet is best known for its bentwood chairs, particularly the Number 14 chair from their 1859 catalogue (Thonet themselves have produced over 50 million of this chair, and numerous copies have made it one of the most widely pro-duced furniture designs ever). From the turn of the century, Thonet was also associated with great designers, notably Adolf Loos and Otto Wagner. With its great Viennese rival J. & J. Kohn, Thonet ruled the market for designed European furniture (Thonet and Kohn, in fact, eventually merged to form the even more powerful Thonet Mundus in 1923).

By the end of the 19th century, Thonet had begun to expand beyond its domestic and restaurant ranges. In the 1904 catalogue, for example, special barber's chairs and invalid furniture is displayed, as well as church, children's and garden furniture. Given this broad range, Thonet naturally did not neglect the office. Most of the designs were merely swivel bases using standard Thonet seats or stools, perhaps with an additional tilt mechanism.

The first of Thonet's successful collaborations with leading designers and architects was with Otto Wagner. The great Viennese architect used

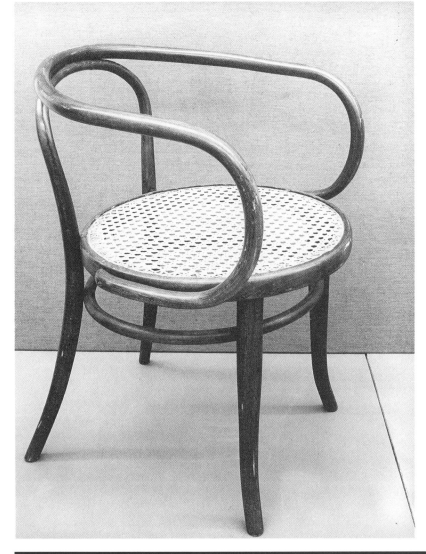

Left: Classic Thonet: the 'B9' armchair which proved one of the favourites of the Modern Movement.

Right: In the 1911 catalogue, Thonet's diversification is clear. Chairs and stools of all heights, with a wide variety of seats and bases create a complete range of furniture.

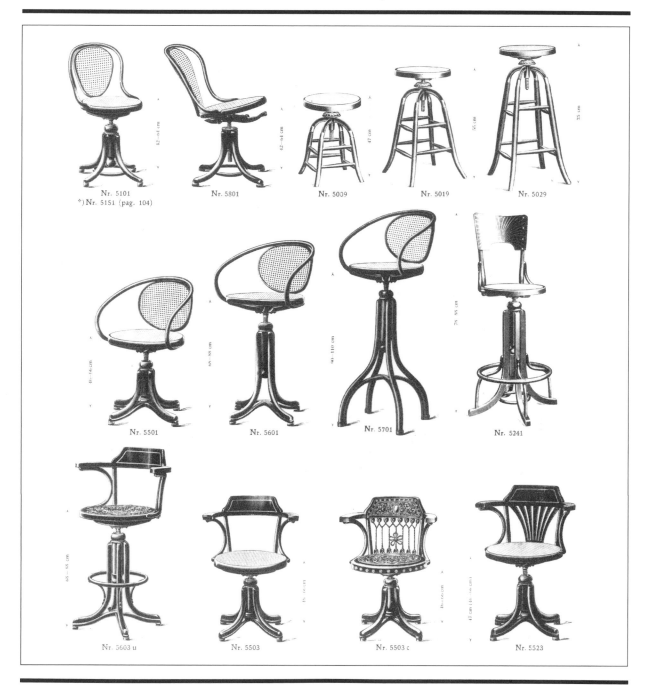

Nr. 5101
*) Nr. 5151 (pag. 104)

Nr. 5801

Nr. 5009

Nr. 5019

Nr. 5029

Nr. 5501

Nr. 5601

Nr. 5701 c

Nr. 5241

Nr. 5603 u

Nr. 5503

Nr. 5503 c

Nr. 5523

Right: Despite the innovative architecture of Wagner's building, the offices still seemed little more than updated versions of the early 19th-century office, including the chaise longue in the corner for the idle executive.

Below: For the Vienna Postal Savings Bank, 1904–06, Otto Wagner designed a range of office furniture. The armchair was subsequently manufactured by Thonet, and is still available today as an expensive designer cult object.

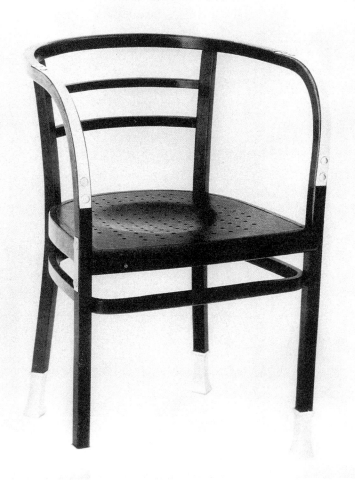

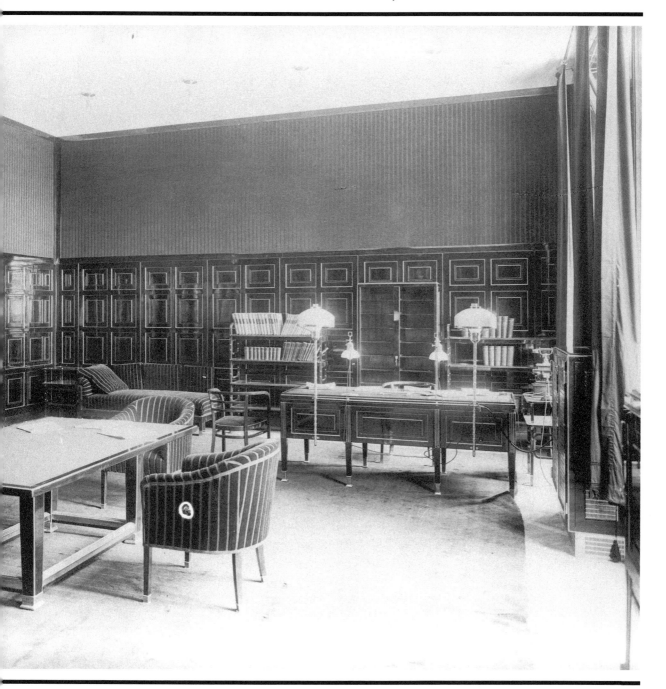

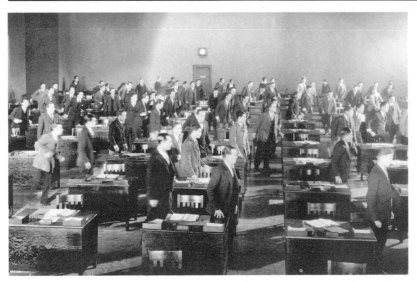

Despite the widely perceived alienation and conformity in the modern office, few of the great architects in the early years of the century turned their attention to the problems, preferring to concentrate on housing. King Vidor's 1927 film The Crowd *is perhaps the best tract against the office of the '20s.*

The same could be said of the next major instance of Thonet's collaboration with great designers. The classic simplicity of many Thonet designs, and their flawless use of materials, made them a standard for many of the architects of the Modern Movement in the years after World War I. The design world's canonization of Thonet's simple bentwood forms, in fact, can be traced to Le Corbusier's use of their chairs in his influential Pavillon de l'Esprit Nouveau at the 1925 Paris Exposition des Arts Décoratifs. Le Corbusier explained his choice of Thonet in persuasive terms: "*We have introduced the humble Thonet chair of steamed wood, certainly the most common as well as the least costly of chairs. And we believe that this chair, whose millions of representatives are used on the Continent and in the two Americas, possesses nobility.*" So it is not surprising, given its pedigree, that Thonet was the company that eventu-

Thonet to make the furniture for one of his major works, the 1904–06 Vienna Postal Savings Bank. Many of the designs were subsequently put into the standard Thonet catalogue. The small, cubic stool for the banking hall was exemplary in its spare use of materials. Four rectangular pieces of bent wood, all square in section, were used for the sides. The veneer top, with a rectangular slot for easy carrying, was fixed to a square piece of bent wood. All hardware was aluminium, just as the building's architecture used aluminium details

throughout.

In addition to the Wagner pieces, Thonet made a number of chairs and tables to the designs of Marcel Kammerer, Wagner's assistant on the project. Although there is an undoubted elegance to all of these designs, and they remain available at a high cost to design *aficionados* even today, neither Wagner nor Kammerer were concerned with providing furniture appropriate for office work as opposed to any other endeavour. Their concern was merely to create well-designed chairs for general use.

Opposite: One of the rare giants who did treat the office seriously was Pierre Chareau in a series of true originality and not a little eccentricity. His spindly 1927 rosewood desk (top) is mounted on wrought iron legs. The surprisingly advanced 1929 typewriter and adding machine table (bottom) is again of wrought iron, but with leather-covered shelves.

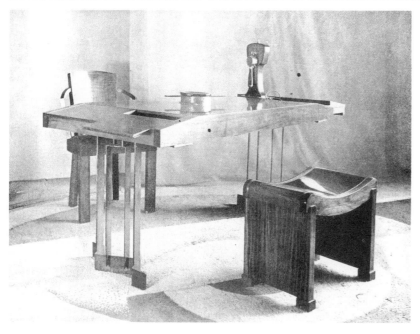

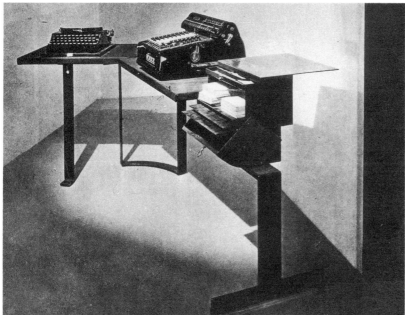

ally became most closely associated with the architects and designers of the Modern Movement. However, it was not bentwood, but the new material of tubular steel that was to be the medium for the new work.

The great ferment in modern design that centred around the Bauhaus in the '20s devoted remarkably little attention to the office. In the aftermath of the First World War, the problem of mass housing seemed far more important and the architects of the Modern Movement focussed their attention on creating a new style of living rather than working (the necessity for corporate clients, as opposed to individuals or governments, in office design may have also been influential in this choice). There were, however, a number of important office design developments provoked by the Modern masters.

Marcel Breuer is generally credited with designing the first

Overleaf.
Left, top and bottom: Even more bizarre was Michel Dufet's 1930 desk of polished zinc made for the head of the Compagnie Asturienne des Mines.

Right: Cover of Thonet's tubular-steel catalogue from the early '30s showing their range of office furniture by Breuer, Le Corbusier and Charlotte Perriand.

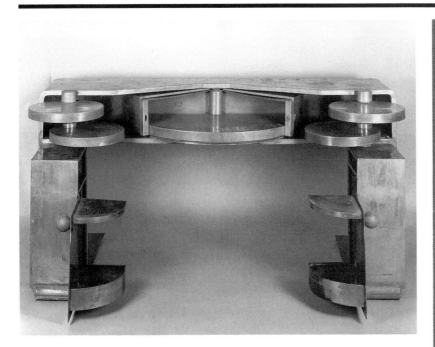

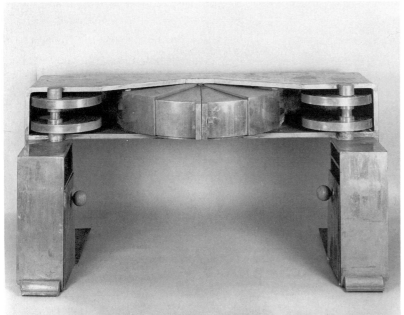

Marcel Breuer pioneered the use of tubular steel for furniture. The designs were simple and direct: the 1927 Thonet 'B5' was shipped knocked down with 100 in a box one metre square.

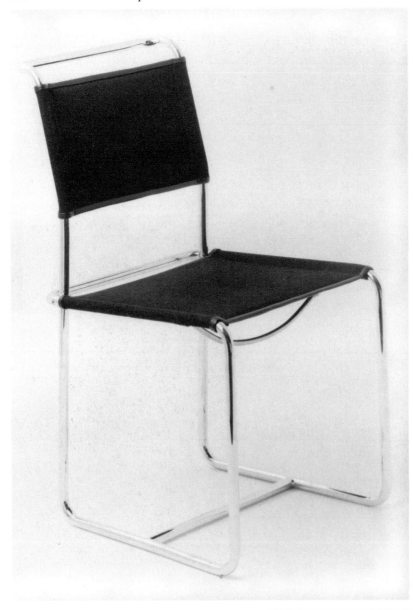

chairs using tubular steel, which were manufactured by his own company, Standard Möbel. Most of their production was intended for domestic use, though many are now common sights in office boardrooms or for visitors' chairs. One of the Standard Möbel range, however, was intended for the office. But curiously, despite its modern materials, Breuer's 1926 office chair was hardly innovative. On top of the four spindly tubular steel legs, the swivelling chair was made of a flat seat and back, connected by two bent tubular steel supports. Breuer's design displays far less understanding of ergonomics than was shown in Ten Eyck's chair of 1853.

Standard Möbel was started by Breuer because of his unsuccessful attempts to find another manufacturer. The company unfortunately fared poorly in marketing his designs and in 1928 Breuer sold the rights to some of his designs to Thonet. Following this agreement, Thonet took over Standard Möbel and by late 1928 began producing their first Breuer tables and chairs.

Most of Breuer's work for his own Standard Möbel, and sub-

Right: Breuer's office desk exploits the sinuous qualities of the tubular steel and exhibits a bit of swagger with its suspended drawers.

sequently for Thonet, was designed for the home. The same was true of work by other leading designers and architects, though Thonet's sales to commercial organizations was important for their business. Other than Breuer, the only conspicuous office designs in this pioneering period were the 1930 'B302' and 'B303' swivel-ling chairs by Charlotte Perriand and Le Corbusier.

Just as Thonet's success with bentwood furniture in the 19th century had led to many imitators, so in the late 1920s and early 1930s furniture companies across Europe began assiduously copying Thonet's tubular steel designs and evolving work of their own.

Perhaps the most interesting of the tubular steel furniture manufacturers was the Dutch company, Gispen. Willem Gispen, a designer active in the generation that included Johannes Duiker, Mart Stam and Piet Zwart, had originally established his Art Metal Factory in Rotterdam in

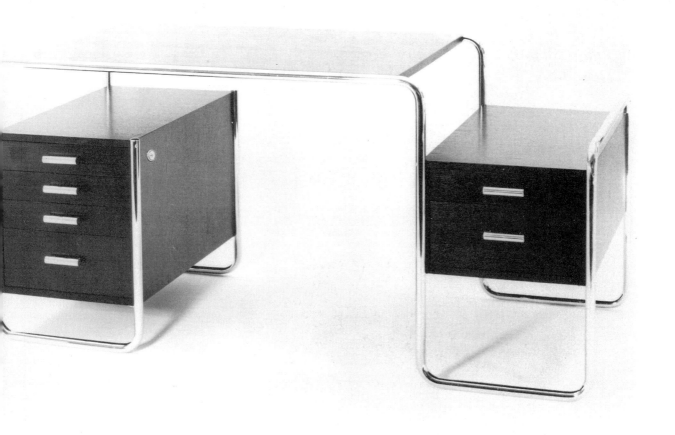

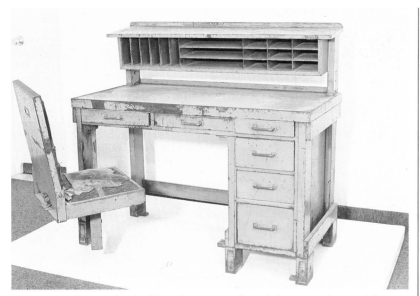

Above: Wright's Larkin building furniture reflected the most advanced design thinking in the first 30 years of the century. Below: The style of art nouveau furniture is usually not associated with the office, but in 1898 Henry Van de Velde designed this massive oak desk and chair.

1916, to manufacture his own street and domestic furniture. But like many of his peers, in the 1920s Gispen began to gravitate away from the decorative traditions of Berlage and van der Meij towards the more spare aesthetic of the international Modern Movement, particularly under the influence of Mart Stam.

Gispen exhibited some of his early tubular steel chairs for domestic use at the 1927 Weissenhof housing exhibition in Stuttgart, where Le Corbusier, Stam and Hans Scharoun all used Thonet bentwood chairs in their demonstration houses. The

Above: Although it lacks the refinement of Breuer's and Mies' work with Thonet, the 1930 typing desk by French designer Jean Burkhalter uses tubular steel in a perfectly utilitarian manner to form an eminently practical office desk.

most important development for Gispen, though, was the building in Rotterdam of the new factory and office complex for Van Nelle, designed by architects Brinkmann and Van der Vlught. This building, completed in 1929, was one of the

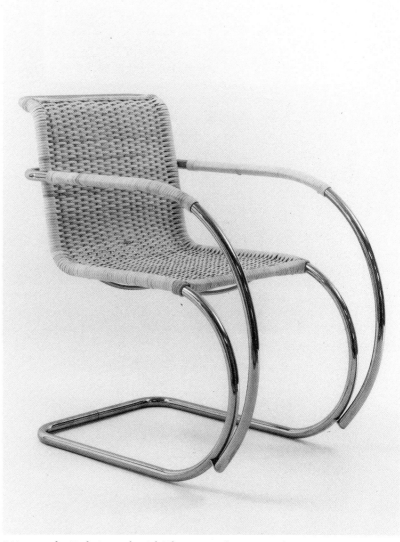

Mies van der Rohe's work with Thonet was less severe than Breuer's. His 'MR 534' chair was designed in 1927 after Mies had seen a sketch of Dutch architect Mart Stam's cantilever chair.

pioneering architectural works of its time. Gispen furnished the entire complex with his tubular steel furniture and lamps.

Gispen himself designed the steel typewriting desks and chairs for the main offices. For the executive offices he designed a combination office and dining chair in diagonal bent tubular steel, upholstered in leather. Although Stam, as well as Breuer and Mies, had used tubular steel to create cantilever chairs, Gispen felt many people did not like the rocking move-

Right: PEL's 1933 half-upholstered armchair is a decidedly ungainly, inelegant version of Charlotte Perriand's 'B302' for Thonet.

Below: Wells Coates' 1933 PEL desk uses the curved chromed steel frame to hold the sets of suspended drawers, similar in form to Breuer's desk (see page 33).

ment of the cantilever and introduced a diagonal support. "*The normal way, when you want to stabilize a construction of three or four metal tubes or bars, is by the insertion of a diagonal. To attain the stability I therefore let the diagonal go from front bottom to back seat.*"

In Britain, two companies in particular, Practical Equipment Limited (PEL) and Cox & Co, became major disseminators of the Modern style in furniture. Like Thonet and Gispen, the British companies concentrated on the production of domestic furniture, but office furniture, too, was made, both as standard ranges and as special commissioned items.

In PEL's work in the 1930s a number of designs reveal the Continental influence. A half-upholstered armchair bears a strong resemblance to Thonet's 'SS33' (attributed to the Luckhardts), another chair to Charlotte Perriand's 'B302' Thonet chair, and a swivelling office chair of 1933 is similar to the Thonet 'B7'. The desks are perhaps more original. The

Right: The pervasive appeal of PEL's tubular steel furniture extended even to a 1935 automobile showroom and service station in Catford, South London. The furniture clearly symbolized the clean, modern, technological world, like the motor car.

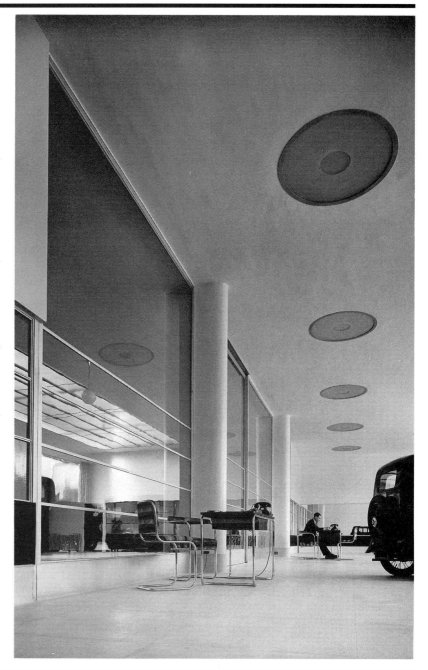

architect Wells Coates designed a six-drawer desk for PEL in 1933, catalogue 'SD1', with the two sets of drawers held in the curved chromed steel frame. With a walnut top, PEL was selling Coates' design for £28 in 1936. Cox & Co, Britain's other leading modern furniture company had designed a slightly similar, though less elegant single pedestal tubular steel-framed desk in 1930, catalogue 'M68'. Cox's 'Stronglite' range of office furniture contained, like PEL's, highly derivative chairs as well as the more typical, and less designed, typist's chairs like their 'OW 103N'.

PEL's great rivals, Cox & Co, used their steel expertise to create the glittering telephone room furniture in the 1936 Daily Express building. But for all the sparkle and chrome, the chairs were little different to those of 40 years earlier (see page 21).

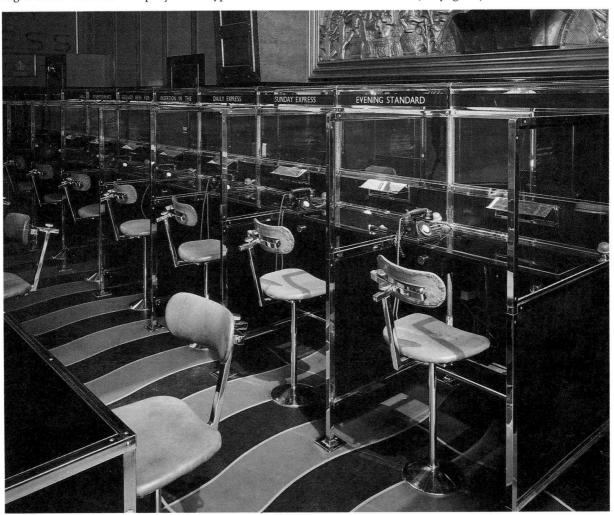

FRANK LLOYD WRIGHT:

JOHNSON WAX

JUST as Frank Lloyd Wright's Larkin building in Buffalo marked the true beginning of 20th-century office furniture design, so his work for S. C. Johnson & Son in Racine, Wisconsin, in the '30s proved another landmark in office design. The administration building of the Johnson complex was designed by Wright to be a modern-day cathedral for the workers. In all of his works, Wright preferred to design all aspects of the environment, including the furniture. So from an early meeting on the Johnson project, Wright suggested that he add the furniture to his commission.

The development of Wright's designs for the Johnson furniture is described in detail, particularly the business approach, in Jonathan Lipman's definitive monograph on the building. Wright was warned by Johnson's general manager Jack Ramsey that the furniture had to meet the company's requirements 'both as to practicality and expense'. Wright's

interest in doing the furniture was indicated by his willingness to cut his normal 20 per cent charge for furniture design to his architectural charge of 10 per cent. But when the building works began running over early estimates, Ramsey understandably became even more nervous about the cost of special furniture.

"As to furniture, therefore, how can we get anything new? Money is an irritating part of this world, but we've got to take it into account – not for piling up gold for its own sake, but just so that this business continues to run properly and serve the very human destiny that it has for fifty years. And — this is difficult to express, because I do have the greatest belief in the architect — even if we could splurge on some new furnishings, to accept blindly in advance whatever you might give us in the way of such pragmatic items as office furniture."

Wright tried valiantly to turn the tide in his direction.

"I've been thinking a lot about furniture — and have been scribbling around the matter. Am I going to be able to sell you my devoted heart and soul in this meticulous matter in connection with our great building? It would mean a lot of patience on your part as on mine, but I think less so, ultimately, than to try to adapt or accommodate stock-stuff. I am for it if you are."

But this attempted persuasion only prompted advice to go ahead with furniture designs, without an advance.

Wright designed 40 different pieces of furniture for the Johnson building. Not surprisingly, from the first designs, his furniture closely reflected the building's architecture, blending rounded and straight forms. The desks' three oil-polished, wood

worktops were extended well beyond the edges of the aluminium frame, echoing the building's own cantilevers. Above the desks, pigeon-holes for temporary files were also cantilevered, with an integral lighting tube to provide task lighting for the worktops. Round drawers swivelled out from the desks. The chairs were also in aluminium, with a leather seat and back. As in the Larkin building, the chairs had three legs, but the unstable two front legs, with one back leg used in 1904, were modified by Wright to two back legs, with one central front leg.

Wright had originally contacted furniture manufacturer Stow-Davis in Grand Rapids, Michigan about the Johnson furniture, but when they saw the primarily metal designs, they withdrew because their expertise was in wood. Two furniture makers who specialized in metal were drafted in: Steelcase Inc. and Warren McArthur. Both produced prototypes, but Steelcase were awarded the contract in

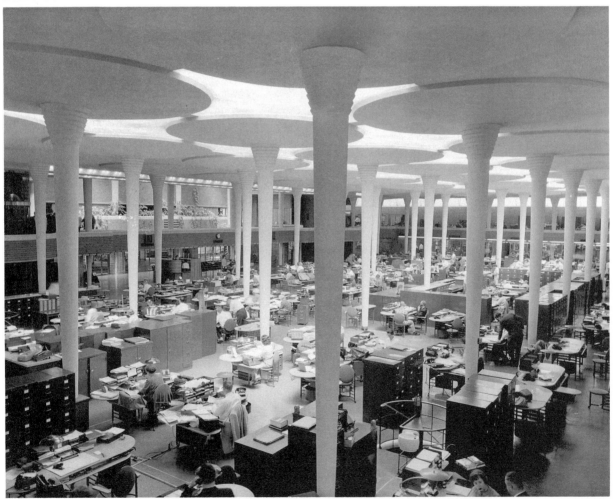

June 1938.

Although Wright's original designs had specified aluminium for the frames, both McArthur and Steelcase produced pieces using tubular steel, a material far cheaper than Wright's

Left: The Great Workroom at S.C. Johnson & Son, designed by Frank Lloyd Wright, 1937–39. A modern-day cathedral for workers, offering light, space, air and inspiration. A true indicator of the design's effectiveness is how Johnson staff still retain immense pride in the wonder in which they work.

milled, welded heavy sheet-aluminium. The use of tubular steel had of course been well established by Marcel Breuer, Le Corbusier and Mies van der Rohe.

In addition to the striking design of Wright's furniture, there were a number of important departures from current convention. While typical office furniture had large bases covering the floor, Wright had the desk legs narrowing at the base. Wright's advocacy of the three-legged chairs was based on his belief that they would encourage good posture: if users sat incorrectly, the chair would tip over. Both seats and backs

The achievement of Wright can be seen most clearly by comparison with another landmark of the same date. For all of its size, the Empire State Building was completely conventional inside: scores of little rooms interspersed with bullpens for secretarial and clerical workers.

were padded with foam-rubber. The pivoted back, with fabric on both sides, was designed both for added comfort and for decreased wear on the fabric. Four fabric colours were chosen by Wright for different departments. In the Great Workroom, the

Wright's 'Johnson' desk and chair, made by Steelcase. The original three-legged chair was changed to a more subtle four-legged chair with Wright's approval.

had deep and wide openings for the files with a sliding wood insert to provide a small working surface over the files. A small rolling stand allowed the heavy ledger trays to be moved from a central filing area and placed in the hanging bins of the desk for temporary use. Wright also designed square, rectangular and round tables for other departments, as well as special one-off items. The most spectacular was the information desk, located at the junction between the lobby and the Great Workroom. The 28-foot long (8534 mm) maple surface of the desks is divided into two parts. On a tubular frame, the straight surface serves as a display stand with mail pigeon-hole behind; a semicircular surface provides a receptionist's desk and room for a telephone operator.

The originality of Wright's furniture designs in the Larkin building was such that it took several decades for more conventional designers to catch up. Such, too, was the scale of Wright's accomplishment in his furniture for Johnson. Aside from the aesthetic sophistication of the design, they can be identified as clear forerunners of the open office furniture of the '60s, not least in the sophistication of their paper storage. Furthermore, Wright's organic connection between the architecture and furniture of his building answered many of the complaints later to be voiced about systems office furniture.

red fabric of the chair cushions provided one of the few touches of colour. The steel frames of the furniture throughout the building were painted Cherokee red.

Despite Wright's convictions about the advantages of the three-legged chair, the users remained dubious – a number of employees apparently fell out of the chairs in their first few days in the building, but they soon learned to use them properly. Because of this experience (Wright, too, supposedly fell the first time he sat in one) Wright subsequently designed a four-legged lounge chair, as an

'officer's chair'. Visitors in the executives' offices were thereby spared possible embarrassment. The worries about the three-legged chairs nevertheless persisted, and the company later installed two front legs on most of the remaining chairs, a modification Wright approved.

The basic desk had nine variations, for different tasks (reminiscent of the highly specialized furniture of the turn-of-the-century). Most desks were 84 inches by 32 inches (2130 x 813 mm), considerably longer than standard desks. Perhaps most impressive were Wright's tub desks, which

ORGANIZATION MAN

ONE of the decisive ironies of our century is the transformation of the Modern Movement, from a radically based approach to design, largely inspired by the needs of the working class in the turmoil following the First World War, into the perfect encapsulation of corporate style. The development of steel structures and the need to maximise lettable office space on expensive urban sites made large, clear floor spaces both desirable and possible. This, in turn led to a rethinking of the design of office furniture. Such a form of office building had been foreshadowed by Ludwig Mies van der Rohe in 1919. His project for an office tower on Friedrichstrasse, Berlin, envisioned a towering glass block on a triangular site. Office space was in three wings, clustered around a central core for lifts and staircases. Although the free-form plan of the Friedrichstrasse scheme was never to be realized in his

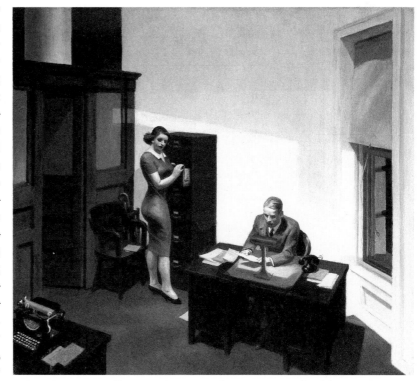

Edward Hopper, Office at night, *1940. The corporate style of the post-war era was in part a reaction to the slightly claustrophobic atmosphere of traditional office buildings.*

lifetime, Mies was able to achieve many of the aims of this project with the Seagram building, New York, 1954–58.

The Seagram building set the pattern for the office building of the next 20 years: a tall, steel-framed tower, set back on its plaza, with a gleaming

Left: Mies van der Rohe's Seagram building, 1945–58, became the paradigm of the office building. The tall, steel-framed tower, elegantly set back on its plaza became the image of the corporate world.

Below: The interiors of the Seagram building reflected the calm, classical ordering of the architecture.

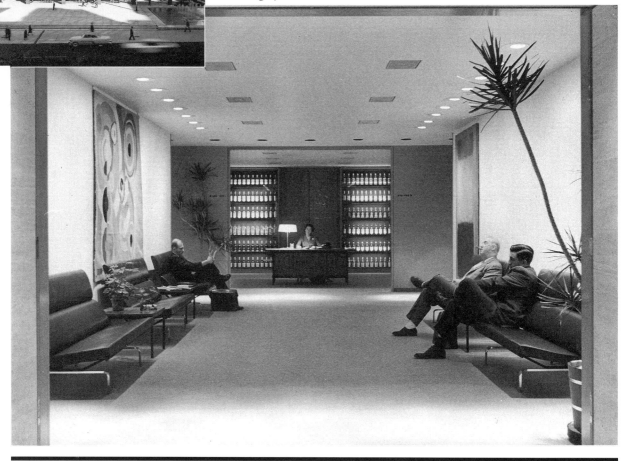

glass curtain wall. A typical office floor in the building had a core for

In an oak-panelled executive office at the Seagram building. Mies' own furniture predominates.

lifts, staircases and services and the office space was ranged around the perimeter. Although the Seagram building was not the first steel-framed, curtain-walled office tower (Skidmore Owings and Merrill's Lever House, 1950–52, deserves that

honour), the *imprimatur* of Mies and the severe elegance of the structure ensured its primacy as an influence.

For the large corporation, with massed ranks of white-collar workers, this proved to be the perfect architecture from which new forms of

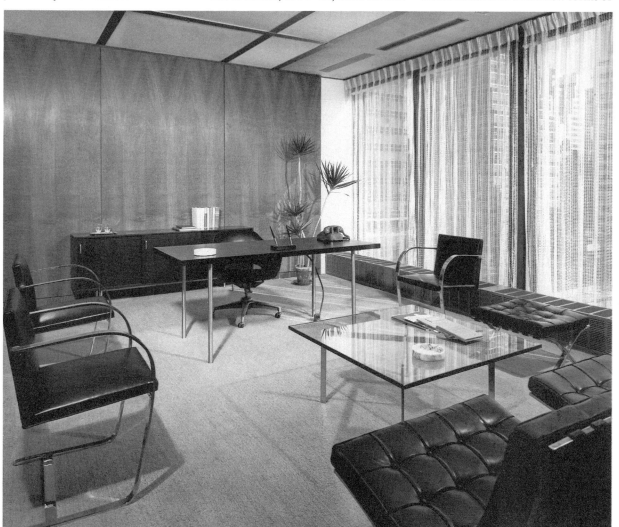

office design could develop. Initially, though, companies adapted the traditional forms of office design to this new building type. Deep office spaces were made possible through the availability of efficient fluorescent lighting (thanks to military research during the War) and air conditioning. Full-height walls constructed within the floors divided the space into cellular offices for executive staff, who were placed, for preference, along the perimeter beside the windows. Clerical staff were ranged in large bullpens of carefully ordered desks on the interior.

The archetype of this style of office was designed by Skidmore Owings and Merrill (SOM) in 1959 for Union Carbide. In their tower on Park Avenue, just down the street from Mies' Seagram building, Union Carbide were given offices that reflected the rigid hierarchies of the

The apotheosis of the '50s office interior at SOM's Union Carbide headquarters. All elements, furniture, ceiling, filing, partitions, scrupulously conform to the rigid design module.

corporation. All furniture was either custom-designed or adapted specially from standard ranges. SOM designed the interior as a careful assemblage of coordinated parts: ceilings, lighting, desks, partitions, chairs and storage – all on a 2½ft module (a module is a unit of size, used to standardize planning and design). So thorough was the architects' approach that even desk sets and ashtrays were subject to minute scrutiny.

Desks were basic metal frames with modesty panels and laminate tops. Visitors' chairs were designed on a similar rectilinear basis, while

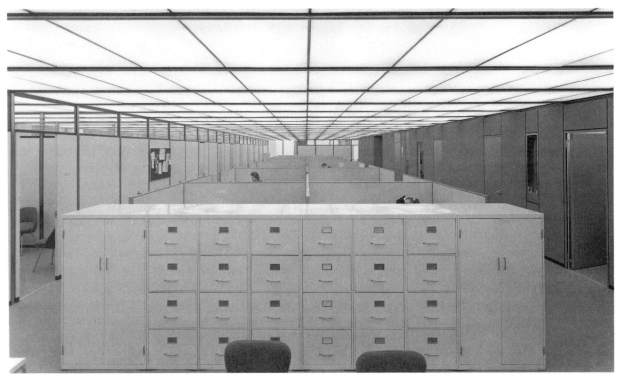

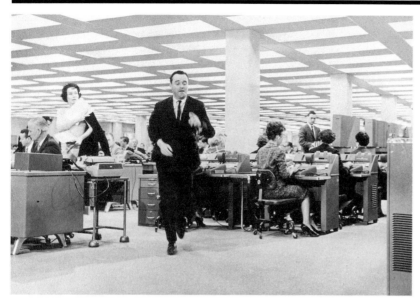

Billy Wilder's 1960 film The Apartment *immortalized the '50s office environment. How little had changed from the office of King Vidor's* The Crowd *(see page 28).*

typists used standard chairs. One of the most innovative aspects of the design was the suspended ceiling, which realized a Modernist dream of a continuous plane of luminosity. But the ceiling at Union Carbide did more than provide light: it acted as a sound barrier and provided fixings for the partitions and supply and return ducts for conditioned air. Lightweight internal partitions were better detailed than usual, for the supreme module of the design ensured that everything fitted carefully into place.

The furniture at Union Carbide was only one means of expressing the corporate hierarchy. As executives moved up the ladder, they moved from internal windowless offices, to single-windowed offices, to the final triumph of a corner office. With promotion came larger office sizes, larger desks, larger and 'more comfortable' chairs. So refined was the structure of status symbols, that even the type of rug, artwork, desk set and tea service was a certain indicator of corporate role.

Although Union Carbide and its many imitators encapsulated the dominant thinking on office interiors in the '50s, a number of designers had begun work in the years just after the War to devise furniture for a new era. The importance of the late '40s and early '50s in office furniture design can hardly be overstated, for the developments of these years began a break with the standard forms and designs that had lasted for a half century.

The static nature of office furniture design at this time can best be understood by the reception given in 1947 to George Nelson's 'Executive Office Group', (EOG) for Herman Miller Inc. – the first major new development away from traditional office furniture design. As Nelson has pointed out in his own writings, despite numerous variations, office furniture from the late 19th century had basically consisted of wooden two-pedestal desks, rolltop desks for the management and a variety of chairs and tables, also in wood. But the 'EOG' introduced a new feature: an L-shaped desk, with one arm of the 'L' at typing height. To accommodate workers in the 'L', the old, two-pedestal desk was replaced by one with storage at the ends, and a clear space at the angle between the two arms. Although numerous developments were to take place in the 40 years after Nelson's design, he had provided the first example of what came to be called a workstation.

The 'EOG' and its subsequent developments are interesting for more

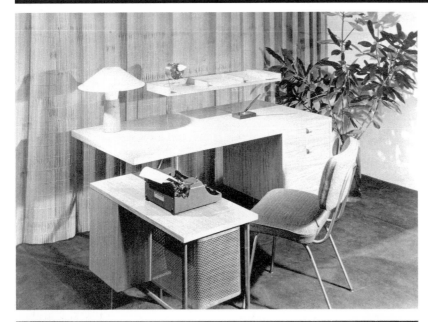

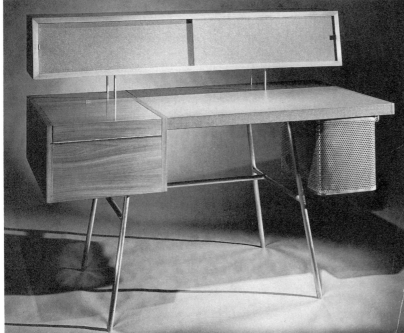

George Nelson's 'Executive Office Group' for Herman Miller originated the L-shaped desk with typing return.

than conceptual reasons. Many details of the range were innovative. A typical desk had a container for a portable typewriter on one side, with a hinged top that opened out to become the typing return. Once open, the typewriter compartment was revealed to be filled with all the necessary typing materials. More striking were the perforated metal sliding file baskets.

A 1952 Herman Miller catalogue lists the supposed advantages of the 'EOG': it eliminated the bulky, traditional knee-hole desk replacing it with a 'free-floating' work surface; all storage was accessible from the desk and necessary accessories were built-in, such as the pivot-arm fluorescent desk lamp and the desk-height file drawer. The rest of the office was thereby freed for informal seating for discussions and conferences. In many ways, this list presages the many

Left: The rather spindly features of Nelson's design are characteristic of the '50s. The hinged container on the left of the desk was for a portable typewriter: opened out, the top becomes a small typing return.

advantages cited for later office furniture developments, notably Miller's own 'Action Office' in the '60s.

Herman Miller's importance in this era can be gauged by their other main office product, the 'Eames Storage Units'. Like many designs by Charles Eames, the storage units, or 'ESUs' as Miller dubbed them, were not originally intended for office use. But the simple frames of plated-steel upright supports carrying plastic-coated plywood shelves were adapted to act as desks. With their crossed metal struts for stability (though this was never the most stable of designs, having stretched lightweight construction a bit too far for heavy use), the 'ESUs' acted as models for the later fashion for High Tech design in the '70s.

The 'ESU' was just one of the seminal designs developed by Charles Eames, usually in partnership with his wife Ray. Charles and Ray Eames were the greatest furniture designers of the post-war years. Unlike many of the designers that were to follow them, the Eames rarely, if ever, worked to a commercial, marketing-orientated brief. Instead, they chose problems that interested them, often suggested by friends, and devised solutions that pleased them. Their sol-

The 'Eames Storage Units' were analogous to the famous steel-framed house Charles and Ray Eames built for themselves in 1948: lightweight, inexpensive materials, assembled in a direct, simple fashion.

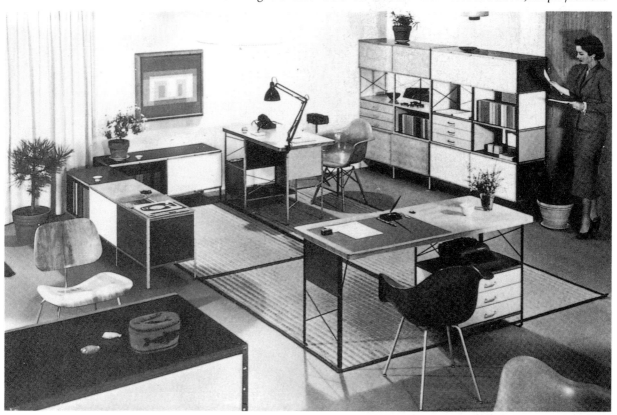

utions, however, did not end with sketches on paper, for they also made the necessary tools to manufacture their works and, in a number of cases, actually produced the furniture themselves. The majority of the Eames' furniture designs were created for the home, but the enduring strength of their design (and, unfortunately, the increasing cost of the products over the years) has meant that their pieces have become as classic in the office as in the home, like Le Corbusier's and Mies van der Rohe's work before.

The essential grounding for the Eames' profound contributions to design came in the years before the Second World War, in their work with Eero Saarinen. They entered the 1940 exhibition and competition 'Organic Design in Home Furnishings' at the Museum of Modern Art in New York, with work that included three plywood chairs moulded into compound curves, made by using thin veneers laminated to layers of glue. During the War, working for the US Navy, Charles Eames went on to develop this original method for forming plywood in three dimensions (the Finnish architect Alvar Aalto had only worked in two) to create a lightweight, low-cost leg splint.

Soon after the War, in 1946, the Eames adapted this technology to create the 'Plywood Group' for a small company called the Evans Products Company. The plywood seat

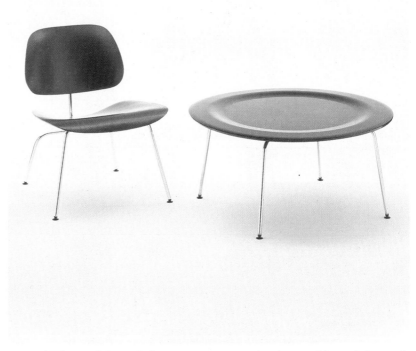

Eames' 'Plywood Group' chair was innovative for the moulding of plywood in three dimensions, as well as the direct bonding process that fixed the rubber 'shock mounts' to the back and seat.

and back were joined to the support and legs by Eames' characteristic rubber 'shock mounts' which allowed for flexing of the parts and provided 'give' for a seated person. Typically of Eames, not only was the use of plywood completely original, but the method of joining the pieces was also innovatory: a metal plate in the shock mount provides a fixing for the legs and back support, but the rubber shock mount itself is fixed to the back and seat by a direct bonding process.

The 'Plywood Group' was exhibited at the Museum of Modern Art in 1946, at the exhibition 'New Furniture Designed by Charles Eames' (Ray rarely was given credit for her contribution). The success of the exhibition led the Evans Products Company to sell the distribution rights for its Eames products to Herman Miller, which had just appointed George Nelson as director of design. Miller went on to purchase the production rights two years later, so cementing their relationship with Eames.

Concurrent with their innovations with plywood, the Eames created the world's first plastic chair. The plastic shell chair, like so many of their designs was widely imitated. But the smooth, simple lines of the Eames' work remain unequalled. In retrospect, one of the most interesting aspects of all of the Eames' early chairs, is the systematic nature of the

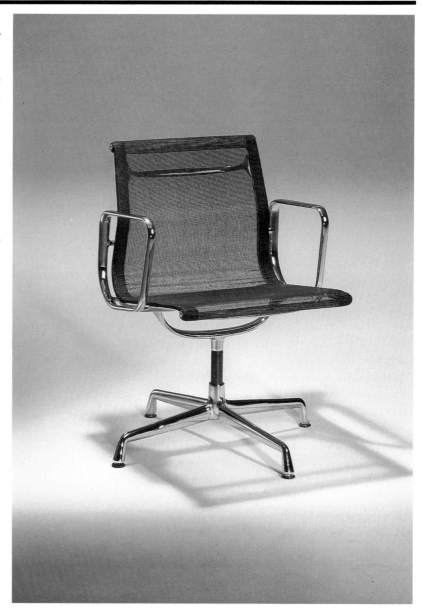

Although originally developed for garden furniture, Charles and Ray Eames' 'Aluminium Group' has become a classic of the boardroom and executive office.

designs. Every seat could fit every base and *vice versa*. But for the Eames the logic of the system was not the marketing tool it has become, but a more simple one. For them, if a base worked it worked; so, too, with the seat. There was no need to reinvent the wheel with every design.

As important as the 'Plywood' and 'Plastic' groups were in the development of chair design, the Eames' 'Aluminium Group' has rightly become their most enduring design in the office environment. As usual with their designs, the brief was a casual one from a friend. Alexander Girard wanted some garden furniture for his new house that could also be used in the garden. Appalled by the current standard of garden furniture, he asked the Eames if they could devise some appropriate furniture. From such humble beginnings the 'Aluminium Group' has developed in stature into the contemporary corporate boardroom classic.

The 'Aluminium Group' is based around two structural ribs of die-cast aluminium that provide the sides of the chair. Between these, the seat and back are slung in one continuous plane. The seat itself is a sandwich consisting of layers of fabric within which is an inner layer of vinyl-coated nylon supporting a quarter-inch thick layer of vinyl foam. These materials are welded together through pressure and a high-frequency current: the welds appear as stripes in the fabric.

The structural side ribs form a bar and flange and terminate at each end in a cylinder. The seat fabric is slipped into the flanges and secured with concealed brass nails, and wrapped around the cylinders at the ends. There is no internal stiffening of the seat pad at its edges, so providing comfort and a good ergonomic solution. One of the curiosities of the 'Aluminium Group' is that for all its technical ingenuity and aesthetic accomplishment, it is an extremely labour intensive chair to construct. The seat pad has to be stretched and bullied into the flanges, the brass nails must be skillfully driven, pushing the seat pad into the cylinders at the top and bottom requires heating and more bullying. Despite this surprisingly inelegant constructional process, the 'Aluminium Group' has proved resistant to imitation, unlike the Eames' plywood or plastic chairs. The expense of manufacture is just too great to make stealing the design worthwhile.

Although the achievements of Eames and Nelson for Herman Miller were without equal in the years directly following the War, one other American manufacturer did make an important contribution to the development of office furniture design. Knoll Associates had its genesis under the guidance of Hans Knoll, a German-born businessman who recognized that the 'new architecture' required contemporary furniture to match. In 1943, Hans Knoll established the Knoll Planning Unit with Florence Schust to carry out a number of interior design projects, including offices for the Secretary of War, Henry Stimson. Florence Schust and Hans Knoll were married in 1946, and in the same year established Knoll Associates.

Florence Knoll had studied at the Cranbrook Academy of Art with Eames, the Finnish architect Eero Saarinen and the Italian-born sculptor Harry Bertoia. She went on to study under Mies van der Rohe at the Illinois Institute of Technology. Before joining Hans Knoll, she worked with Walter Gropius and Marcel Breuer in Boston. These personal links with the giants of architecture and design exemplify the central role Knoll had in the culture of American design.

The most famous products of Knoll from the start, and still today, are their Mies van der Rohe designs. In 1948, Mies granted the production

Mies' 'Barcelona' chair, designed for the 1928 Barcelona Pavilion, was reissued by Knoll in the late '40s and rapidly became an essential for the reception rooms of 'modern' corporations.

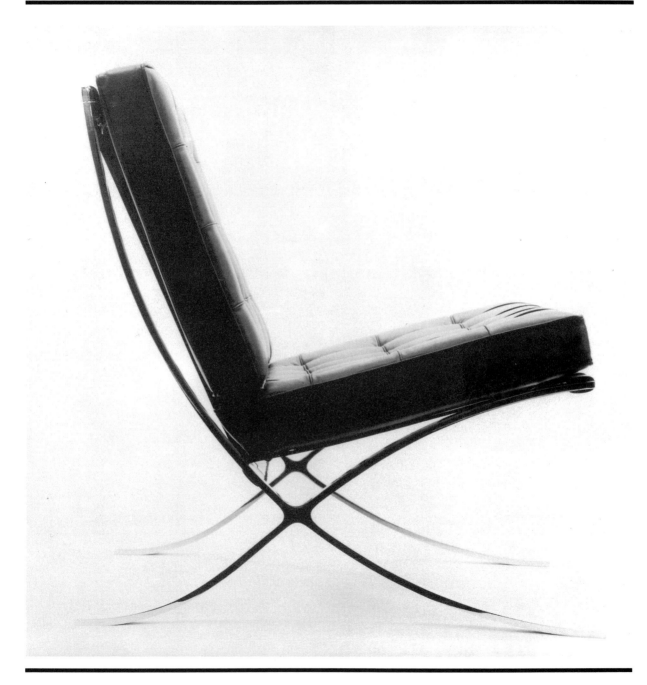

rights to his Bauhaus era work to Knoll and the 'Barcelona', 'Tugendhat' and 'Brno' chairs became widely disseminated classics. Although originally designed for domestic use, as Mies' Modern Movement architecture began to hold sway over corporate America, so too did his furniture come to populate receptions areas and executive suites. With their reissues of Mies' early furniture designs, Knoll were defining the modern standards of good taste and discernment.

Knoll also commissioned new designs from a wide array of designers. The most interesting work for Knoll in the '50s was by Eero Saarinen, the son of the great Finnish National Romantic architect Eliel Saarinen. Saarinen's most famous chair, the 1948 'Womb' chair, was designed for domestic use, but like many of Eames' designs, its greatest success was eventually in the office.

The 'Womb' chair is made in fibreglass-reinforced resin, with a moulded, multi-curved, single-piece shell to form the seat, back and arms. Latex foam rubber and stretched fabric is used for the upholstery, and the chair is supported by a cradle of tubular steel. The 'Womb' chair was supposedly inspired by Florence Knoll's remark to Saarinen that she was 'sick of those chairs that hold you in one position'. The flaring contours of the 'Womb' chair seem to invite the user to slouch and sprawl.

Even more characteristic of a '50s style, was Saarinen's 1956 'Pedestal' collection. A seemingly stress-defying pedestal of metal swoops up from its wide base to join a pressure-moulded polyester seating shell or tabletop. The tulip-like chairs and tables were an attempt to eliminate what Saarinen called 'the slum of legs', which he felt characterized interiors in 'an ugly, confusing and unrestful world'.

When viewed in the context of the achievements of Eames and Knoll's

Right: Arne Jacobsen's '3107' chair was manufactured by Fritz Hansen in 1955. The seat and back are molded in a single piece.

Below: Eero Saarinen's 1956 'Pedestal' chairs for Knoll seemed to defy the laws of structure with their thin supports. The pedestal was made of metal, which was joined to the plastic-coated glass fibre seating shell.

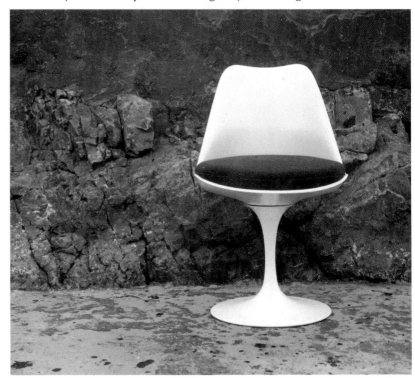

designers, most other developments in seating in the '50s look fairly pallid. There were, however, some salutary exceptions. In Denmark, architect Arne Jacobsen's famous 'Ant' chair of 1954, for Fritz Hansen, has a more zoomorphic shape than Eames' 'Plywood Group' chairs. But the use both of wood moulded in three dimensions and a similar seat on a variety of bases does parallel Eames' work. What distinguishes Jacobsen's chair is the eccentric, wing-like shape of the seat, and the insect antennae arms jutting out from under the seat.

Closer to the Eames chairs in appearance was the plywood chair designed by Egon Eiermann for the German manufacturer Wilde and Spieth, in 1953. What Eiermann's design lacked, though, was the gener-

Right: Shortly after 'Britain Can Make It', the Ministry of Works demonstrated what could be achieved given advances in office design. The before and after photographs of the ministry typing pool are artful, but surprisingly little has changed: slightly cleaner wood desks, typical typing chairs and the adjustable desk lamps replaced by uniform fluorescent lighting.

Below: Compared to the pioneering work of the Americans, most British office furniture in the 15 years following the War is decidedly utilitarian. In the 1946 'Britain Can Make It' exhibition, Richard Sheppard designed an office that boasted small metal desks, wooden chairs and the ubiquitous Luxo lamp.

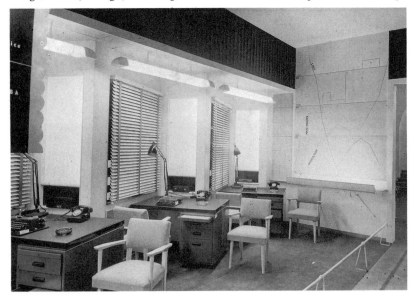

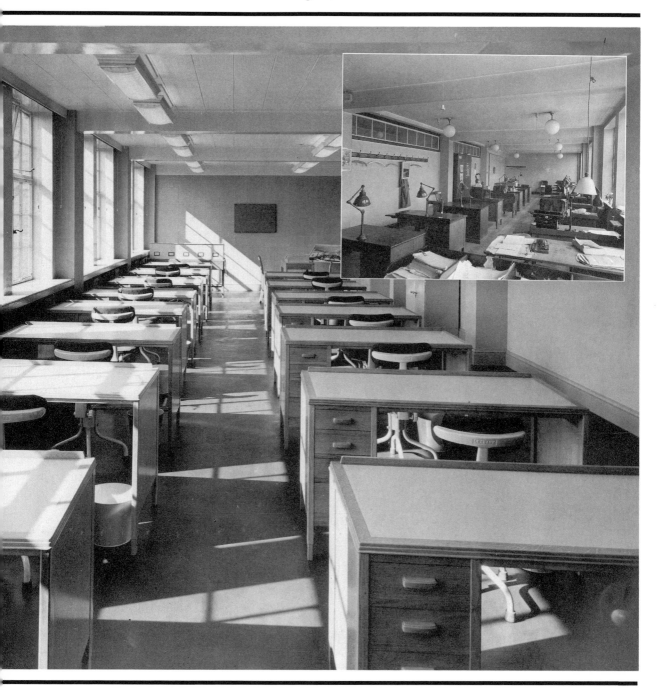

ous proportions of Eames and the resolution of the link between seat and back, using two steel tubes, was decidedly awkward in comparison.

The work of these designers, however, was decidedly an anomoly in the '50s. The general standard of office furniture deviated little from the work of the preceding half century. The demands of mass production had virtually standardized some basic forms: for instance, metal furniture was manufactured in the simplest possible way for the forming of a single steel sheet. As a result, the double pedestal desk, or a filing cabinet, looked the same no matter who the producer was. With specialized furniture, however, a more definite character was frequently achieved. Hence, the rotary card index, by the Art Metal Construction Company, seems to evoke some of the bulbous, smooth lines characteristic of the Streamline Style of the '50s.

Because of the ease of working wood, wood-based furniture could be found in a wider variation of designs, but compared to the work of Nelson or Eames, little of it challenged the basic conventions of office furniture.

Only in special, one-off items often commissioned for special headquarters buildings were works of interest achieved. So the paper construction-like desk by Charles Kenrick was specially designed for the new Unilever headquarters in London. The exoticism of its material reflects well this type of work: of agba wood, the desk is of black bean and the case is of reeded hardboard.

There were also a number of intriguing, more forward-looking one-off designs for office furniture in the '50s. One of the most elegant, reflecting many of the best qualities of Scandinavian design of the period, is the 1956 desk by Danish designer Poul Kjaerholm. The four-square frame is of flat steel plate, with a top and suspended drawer of plywood.

As far as mass-produced office furniture was concerned, by the mid-'50s, some European office designers were beginning to take issue with the American approach. The large, per-

The bulbuous Streamline Style looks of the Art Metal Construction Company's rotary card index.

fectly ordered office space that began to dominate American corporations did not prove so satisfactory in Europe nor particularly relevant: only in the mid-'60s did tall curtain-walled buildings begin to become widespread in Europe. An office design geared to counteract the anonymity of open plan was devised in Germany. Bürolandschaft, or office landscaping, rapidly spread to dominate Europe, and consequently furniture design responded to this need as well.

The decisive change came in the mid-'50s with the work of a German management consulting firm, Quickborner Team, led by the Schnelle brothers. They argued for office layouts that responded to the movement of paper through the office. The results looked odd, with free-flowing lines of communication rather than the rectilinear layouts favoured by virtually all organizations. The characteristic

Many one-off designs of the '50s seem to have a paper-thin visual quality. Charles Kenrick's Unilever desk achieves this with its case of reeded hardboard.

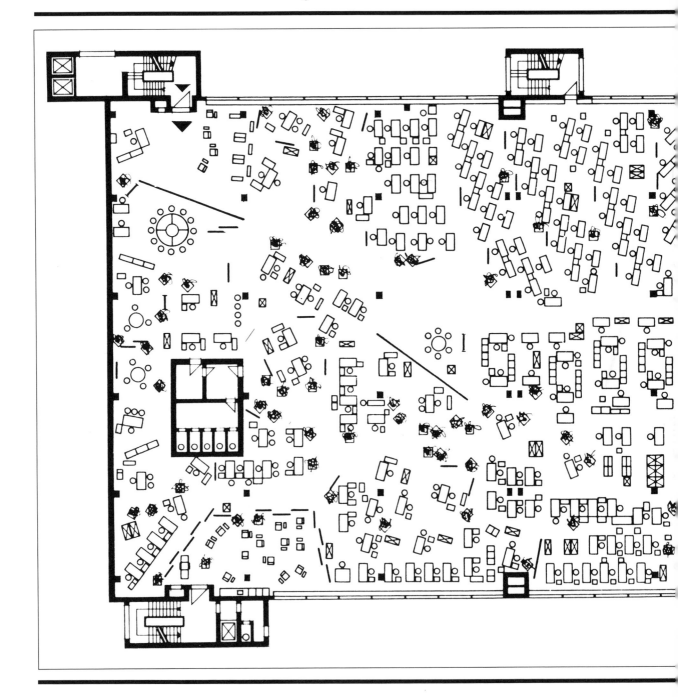

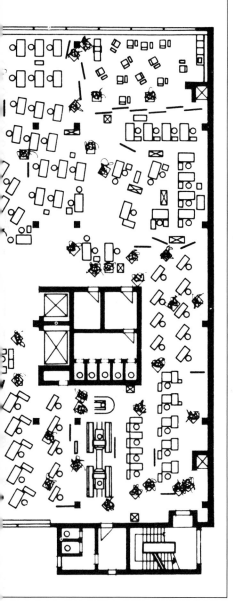

Bürolandschaft office had large, open floor areas, furnished in a seemingly free way, with a 'high' standard of environment, through planting and casual break areas.

The effect of the first reports of this new technique has been well described. Francis Duffy wrote in 1979:

"Nothing had prepared us for those curious German drawings which actually showed desks, hundreds of desks, randomly arranged in great open spaces.... All at once those unforgettable layouts seemed to prove not only that offices were for people but that a superior understanding of how those people worked could lead to revolutionary changes in the shape of the buildings."

Many writers have questioned how novel Quickborner's theory really was, tracing the idea of planning offices around communications and paperflow to an obscure 1913 book *The American Office*. And the rigidly rectilinear American offices of the '50s also claimed to be based on

'Those curious German drawings which actually showed desks.' *The offices for Buch und Ton, Gütersloh, designed by Walter Henn, were one of the early examples of Bürolandschaft.*

analyses of communication. But Quickborner were unequalled in their polemical ability. They published their own journal, *Kommunikation*, as a method for spreading their ideas and they were undoubtedly far more thorough in their development of the concept of relating layout to workflow.

Just as earlier theories of office planning had been largely based on prevailing ideas of management, so Bürolandschaft also had its basis in management theory (Quickborner were, of course, initially a management consultancy, not a design group). The emphasis on creating work groups with their own work spaces, the supervisory advantages of undivided floor areas and the lack of separation of management and staff, all to achieve higher levels of efficiency, has been traced to the influence of organizational psychology on the originators of Bürolandschaft.

But when the disciples of Quickborner's Bürolandschaft came to lay out offices based on these new principles, they found existing furniture did not match their needs. The heavy, bulky desks that were available did not lend themselves to the free plans, and the desire for rapid reconfiguration as needs changed. A few designers and manufacturers, mostly from Germany, Holland and Scandinavia, did respond to the demands of Bürolandschaft with

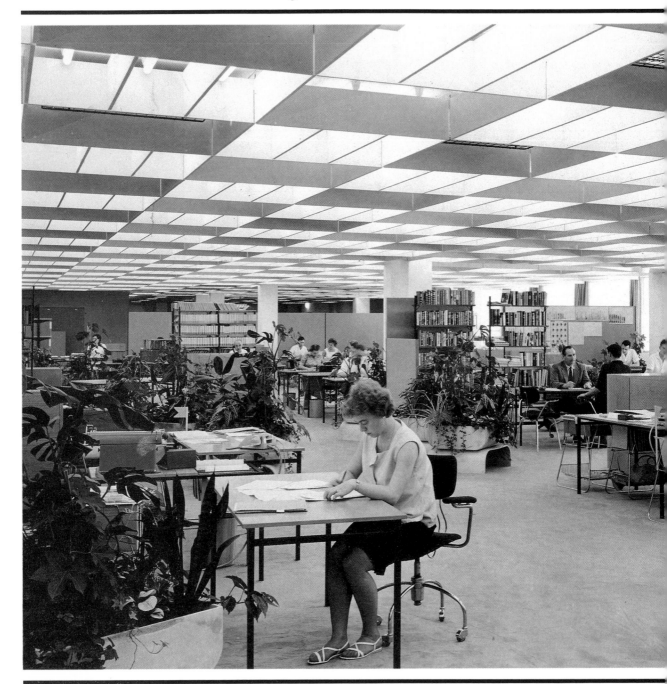

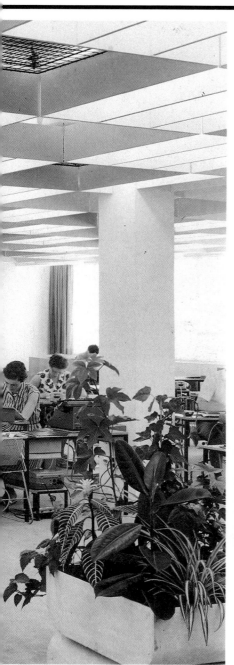

Left: The apparently free-form arrangement of furniture at Buch und Ton conformed, according to theory, to the lines of communication within the office. To facilitate rapid change, furniture is lightweight and the large open spaces have a minimum of structural obstruction.

Below: The almost flimsy looking typist's desk and chair from Magpie Furniture was an early British response to Bürolandschaft design.

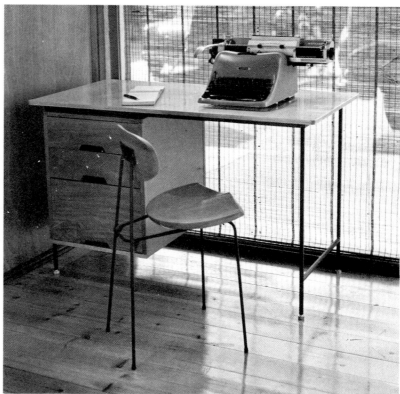

lightweight desks and tables. The new furniture also began assuming new functions like carrying lighting, services and partitioning. The deep plans of the new buildings created for the office landscape had made this essential.

Some critics have identified the aim of Bürolandschaft as bringing the comfort and ethos of the domestic interior to everyone's office. Adrian Forty, for example, compares the differing attitudes in office design of the first and second half of the 20th

century. "*The tastefully furnished director's office in the early twentieth century said, this is a place in which personal relationships and gentlemanly behaviour matter more than purely commercial ones,*" with the implication, "*I am a man of culture and good taste with whom you may be proud to do business.*" In the landscaped office, these messages were translated from individual into corporate statements: "*in this office, it is our sensitive understanding of personalities that makes things go,*" and, "*we are an enlightened corporation, for whom you may be proud to work, or with whom you may be proud to do business.*"

But the apparent democracy of Bürolandschaft was not necessarily real. One of the stated benefits of Bürolandschaft over cellular layouts was the ease of supervision: there was from the outset a clear element in the theory of Big Brother watching over the workers. Regimentation of the individual seemed to be lessened in Bürolandschaft, but quite a few liberties were lost: no personal window to open or close, no light switch to control. The individual had to accept the higher environmental standards of the norm at the expense

More robust, but still easily moved, was the desk range from German manufacturers Holzapfel.

of being able to choose darkness, a draught or a chill.

The open plans of the Bürolandschaft also created difficulties that its originators did not foresee. Noise and distraction were problems, but the key issue raised by the new approach was territoriality and status. Cellular offices, and the relative size of the office, had conferred status on the occupant. The package solution offered by Bürolandschaft ignored the differences in organizations, except on a workflow level. For most companies, the hierarchy needed to be stated; senior managers expected a space of their own.

A solution that would fit between the two extremes of the cellular office and the office landscape was posited in the mid-'60s, but in the intervening years, furniture that was not conceptually radical but interesting purely as product design was widespread.

One such design was Olivetti's 'Spazio' system. Although 'Spazio', designed by BBPR for Olivetti in 1961, looks superficially conventional, there were a number of important design advances in the furniture. 'Spazio' consists of standard modules, allowing up to 20 variations of desks alone. The entire system was evolved with all elements conforming to a simple geometric ratio of 3:4:5. Triangular elements introduce a note

Olivetti's 1961 'Spazio' system had over 20 variations of desks alone, using a simple series of triangular elements.

of the components that could create an office. The basis on which Roepstorff's system was designed was the international 'A' series of paper sizes. As had been the case from the turn-of-the-century, perceptive designers recognized that paper storage posed the key problem of the office environment.

The loose furniture is less interesting than the concept of the system: spindly metal frames mean that desks and filing units seem to perch uneasily on their bases. However, high quality of workmanship assured the interchangeability of parts of the system, while the standard woods – teak, oak and mahoghany – gave the design an appropriate air of gravitas, perhaps at odds with its strictly functional conception.

Although Britain lagged behind many of the Continental developments of the '50s and '60s, one furniture company did play an important

Opposite, top: The modular storage systems of the early '60s reached a peak in the Danish Roepstorff design. All parts of the system were interchangeable, while the dark woods lent an air of gravitas.

Right: Excellent workmanship in Roepstorff was characteristic of much of Scandinavian furniture manufacturing.

of informality to the furniture. The manufacturing techniques were also innovative. Sheeting, tubes and bars, connected by threading, grooving or folding replace heavier steel elements that required complicated welding. To compensate for the weakness of thin steel plate over large surfaces, the entire surface was given a gentle curvature.

There were other approaches developed in Europe in the early '60s that greatly differed from those suggested by Bürolandschaft. Perhaps the most interesting were the modular storage systems of Germany and Scandinavia. A direct parentage for modular systems can be traced from standard office filing furniture and mundane bookcases, but the key difference with the modular ranges was the range of functions, components, integration of style and materials. As one key article on the subject defined it, 'many of these systems add up to environments off the peg'.

The Danish designer Heinrich Roepstorff's system offered storage units, bookcases, filing cabinets, desks and partitioning: essentially all

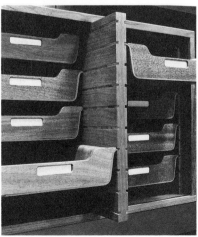

design role. Hille, which had been a reproduction furniture maker from the turn-of-the-century until the War, had spotted the opportunities available in the contract market in the post-war years. Together with designer Robin Day, Hille was deeply involved in designs for the 1951 Festival of Britain. Despite this, the company did not evolve important office furniture of its own until the early '60s. By that time their awareness of the market had developed through their experience with the British license for Herman Miller – theirs since 1957.

Through the '50s, Day designed numerous products for Hille, the most interesting of which were his chairs, first in plywood and then in polypropylene. The plywood chairs, which bear an interesting relationship with the contemporary work of Eames, included the 1950 'Hillestak' with formed back and seat linked by a laminated spine and the simpler 1953 'Q Stak' with a moulded seat and tubular steel legs. Not as adventurous

was the 'Status' office furniture group, which Day designed in 1955. The range borrowed the philosophy of Nelson's earlier 'Executive Office Group' for Miller but without the same attention to detail. As with the fully developed 'EOG' range, 'Status' offered an essentially identical desk with tiny variations to preserve organizational hierarchies: senior management had a full modesty panel, middle management an open knee-hole, and secretaries a single pedestal.

Day's most successful design for Hille was the 1963 polypropylene chair. Although it bears a strong formal similarity to Eames' Fibreglass chairs, the Day design uses a very different material. Polypropylene had been invented in 1954 by the Italian chemist Giulio Natta. Day first encountered it when judging a competition sponsored by Shell to promote the new material to designers. A thermoplastic, polypropylene was

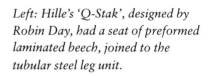

Left: Hille's 'Q-Stak', designed by Robin Day, had a seat of preformed laminated beech, joined to the tubular steel leg unit.

Below: Day's 'Status' range for Hille was in many ways a pared-down version of George Nelson's 'EOG', with none of the panache.

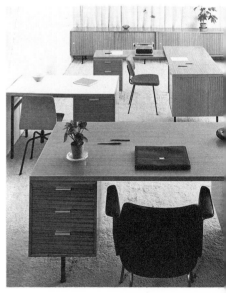

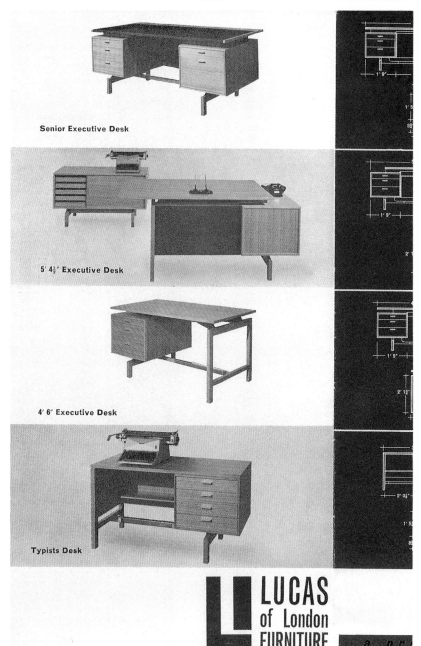

Senior Executive Desk

5' 4½" Executive Desk

4' 6" Executive Desk

Typists Desk

LUCAS
of London
FURNITURE

Lucas of London, with Hille, were instrumental in introducing modern office furniture to Britain. Again the debt to Nelson is clear.

lightweight, had good flexing properties and lasted well. In addition, it could be easily moulded and was ideally adapted for injection moulding. The 'Polyprop' chair, which, shortly after its launch, Day modified to take in some initial criticisms, has been manufactured unaltered since.

In 1963, Hille launched its own Hille 'Storage Wall System'. Like Roepstorff, the 'Storage Wall System' was for apparently universal application: homes, schools, hotels and offices were all intended markets. But the notion of a wholly integrated interior, where walls, shelves, doors and lighting tracks all adhered to a common module and means of fixing had its most important application in the office. Designed by John Lewak and Alan Turville, the 'Storage Wall System' consisted of vertical panels hung edge-on to a pair of wall-mounted, rolled steel channels. Horizontal elements were clipped in between the channels.

Fritz Haller, a Swiss architect, took a different approach using the same notion of a system of elements. The starting point for Haller's design was actually a building system which he developed in 1960. The idea of

Above: The '60s dream of an affordable, infinitely flexible building system: America's 'SCSD' system for a prototype school building.

Fritz Haller's furniture system is built up from a limited inventory of parts, based around the tubular steel structure.

using standardized elements for buildings was a powerful one at the time. In Britain the SPAN structures (a building system used extensively in school construction), were achieving wide currency, and the complicated SCSD system was fulfilling the same function in California.

The 'Haller' furniture system is strongly architectural in concept. The storage units, fundamental to the design, are made from a relatively limited inventory of elements: chromed tubular steel for structure, infill panels (generally a steel sheet) and specially designed ball joints to act as connectors. As with a steel framed building, the structure is assembled first, and other elements are then filled in: shelves, drawers, filing units, doors and vertical panels. Tables are separately treated, though, on the whole, they use the same materials as the storage units. Frames, tubes and legs are chrome-plated steel, and tops and modesty panels are of plastic laminate or veneer.

As with systems architecture, the fundamental idea behind the 'Haller' system is flexibility. The catalogue makes great play of this: "*Each element can be changed and rearranged....Later changes and additions are possible at any time....The Haller furniture system grows with your needs. The initial investment is minimal. You only buy, what you really need. Later you can change and ad-on [sic], or adapt the furniture to your new requirements.*" Architecture systems often promised such capabilities but were rarely

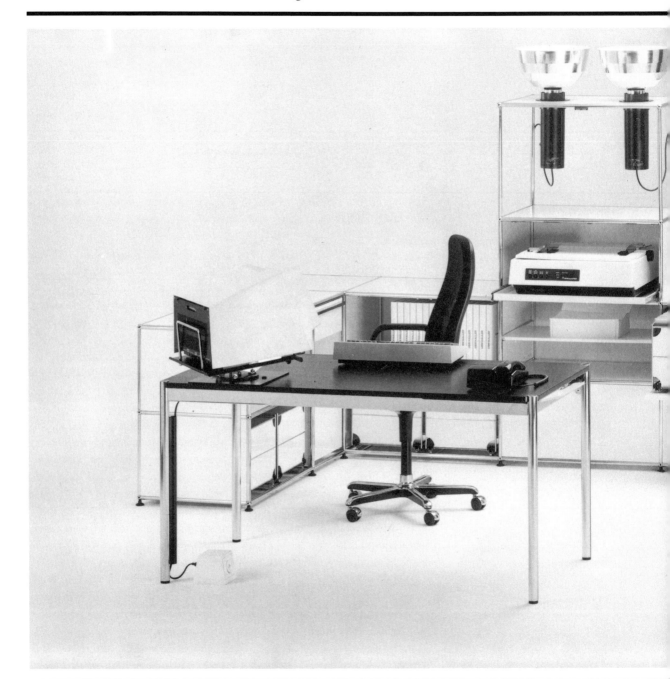

required to deliver. And the additional cost of initial flexibility in large-scale construction and the comparative complexity of such systems led to their early obsolescence. In the office, however, the demand for true adaptability is real and the fact that the 'Haller' system is unique in having survived commercially for nearly 25 years in the office environment is vindication of the importance of change.

For the office chair, the '60s were a rather infertile period. What seems most remarkable about many of the chairs of that decade is how they seemed to turn their back on the understanding of ergonomics that had built up over the past century with the constant variations on the standard typist's chair.

Many designs seemed more preoccupied with defining a new standard of executive elegance. Perhaps the best of these was Charles Pollock's 1965 office chair for Knoll, the

'1255'. Pollock adopted some of the emblems of the Eames inheritance: a shell of plastic, upholstery with built-in creases to indicate comfort (as in Eames' famous lounger). But, befitting the corporate executive, the seat is more than ample, the padding plush and the plastic shell has an exclusive trim of chromed aluminium.

This approach typifies much of office furniture design in the '60s. While every country had its relatively anonymous manufacturers still churning out traditional pedestal desks, a few manufacturers bucked the tide with ranges aimed predominantly at executives and the handful of architect-designed offices. By the end of the '60s, however, there was to be a complete reversal of roles: the traditional manufacturers were scrambling to keep up with the formerly exclusive companies because of the sophisticated 'office furniture systems'.

Left: The much-vaunted adaptability offered by Haller's approach has proved largely true. Alone among early '60s office furniture it has survived into the computer age without drastic modification.

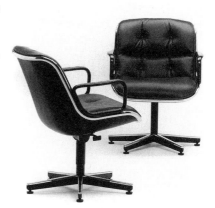

Right: Charles Pollock's 1965 office chair for Knoll emphasized its apparently plush, padded comfort.

'ACTION OFFICE' AND ITS SUCCESSORS

ONE of the most decisive events in the development of office furniture came, curiously enough, through the chance meeting of Hugh DePree, president of Herman Miller, with Robert Propst at the Aspen Design Conference in 1958. Propst did not have a conventional design background, having pursued, at various times, careers as an artist, sculptor, teacher and inventor. But so impressed with Propst's talents was DePree, that Herman Miller formed a research division with Propst as director.

The open brief given to Propst was to find problems outside the furniture industry and to then find solutions for them. Although Propst had ideas in many fields, it was the office that attracted his deepest attention. In a manner similar to the German developers of Bürolandschaft and the Taylorist researchers earlier in the century, Propst tried to examine the office from first principles. His researches are summarized in his book, *The office: a facility based on change* published in 1968, and are visible in 'Action Office', the systems furniture that was based on Propst's findings.

Hidden in the sociological jargon of Propst's book is one of the most influential furniture polemics of the century. To a remarkably prescient degree, Propst foresaw the effects of the information revolution in the office and formulated a comprehensive brief for the furniture the new office would require. "*For most of us the office is a place where we go to suffer a variety of environmental accidents. Some turn out to be advantageous, even to the point of giving unfair leverage over others. Most of the time however, they are bad accidents, wasters of effectiveness, vitality, health, and motivation.*"

Propst's work was in large part a reaction to the International Style offices of the post-war years. The clean, rectilinear, uncluttered offices of Skidmore, Owings and Merrill, Florence Knoll and others were, like the buildings that housed them, designed attempts to hide the differences between organizations and the individuals within them. Propst's reaction was mirrored by other organizational analysts. One of his acknowledged influences was the work of Douglas McGregor, who formulated the Theories X and Y of management (McGregor was also an acknowledged influence on Quickborner Team, the originators of Bürolandschaft). As Propst defined it, in Theory X organisations, "*the bosses set the objectives, exercise control. Ultimate knowledge lies at the top. Independence is discouraged and mistakes call for penalties.*" In Theory Y, however, "*it is natural for people to seek responsibility and...they enjoy it. Performers at any level need challenge and encouragement to gain top performance. Unique knowledge and*

skill lies at all levels in a healthy organisation." Propst's furniture brief was for the new, emerging Theory Y organizations.

Propst's objectives are defined in his book:

1. *"the need for highly permissive surroundings capable of expressing with great pertinence things that count, that identify their very person and serve to motivate"*;

2. *"the size of the [work]station can/should vary radically, but the important thing to recognise is the necessity to separate substantial tasks into established work locations"*;

3. *"the objective is to remove the obstacles to face-to-face communication by providing the proper conversational options"*;

4. *"wiring is part of the office environment and since it is so abundant and must frequently be changed, it has to be a successful, visible, design detail"*;

5. *"proportioning some of our work to stand-up workstations would do more than anything to overcome a sedentary decline"*;

6. *"the reconciliation of privacy requires a new language of enclosure and access. it demands that we preserve, for good reason, the private place with suitable surroundings with much more eloquent design of free access to each other."*

Working with designer George Nelson, Propst produced 'Action Office' in 1964, which was followed by 'Action Office 2' in 1968.

The original 'Action Office' was designed around a T-shaped cantilevered, die-cast, polished aluminium frame. Basic desks had suspended filing accessible at the back of the worktop, using space that Propst had

Propst's polemic is filled with complex graphs and honest photographs showing the actual confusion of a typical office. The office is compared with the city: "Freeway systems that pass over old grid street layouts regain a communications fluidity," according to Propst.

identified as otherwise wasted. Rolltops enabled individuals to hide the 'meaningful clutter' of their desks at the end of the day, for neatness and security. The T-frame could also support shelves and raised worksurfaces, to allow for variation from Propst's hated sedentary position. Small drawers for pencils and pens were mounted under the worktop, but large drawers where papers could be hidden and forgotten were avoided: Propst's research had revealed that once a stack of papers gets three inches high, the bottom papers were condemned to certain inaction.

Details were crucial in the design of 'Action Office'. A thick layer of vinyl covered many of the desks, providing a soft writing surface, and front edges were padded for comfortable leaning. In an attempt to eliminate the clutter of wires that was beginning to entangle office desks, electrical outlets were integral to the furniture. Independent 'communication units' held built-in telephones, and left room for directories, dictaphones and tape recorders.

Some of the reviews of 'Action Office' offer an interesting picture of prevailing design concerns, tinged with the crusading attitude of the Modern Movement. "*One is not entirely convinced that sufficient account has been taken of factors of which many designers will be aware,*" wrote Ronald Cuddon in

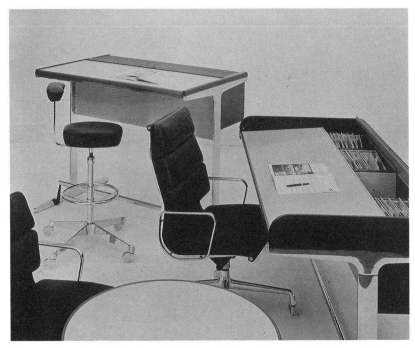

Above: The original 'Action Office' was designed around a T-shaped die-cast aluminium frame. But the expense of its manufacture and the radical leap of its conception, meant it was a commercial flop.

Right: 'Action Office 2' became a staggering commercial success, creating a vast new market for 'office furniture systems'. Aside from radical simplification of the manufacturing process and design elements, the key change was the switch to a panel-based design. Desktops, shelves and storing units all hang off panels that divide space in the office.

The Architectural Review in 1966. "*Namely, the irrational requirements of those unduly worried by status, who express their concern by demanding an enormous desk regardless of function, who require on some pretext more floor space than the* next man to emphasize seniority, whose choice of materials and finishes amplify these human foibles.*" Miller bravely stated at the launch of 'Action Office' that their market was 'the new breed of thinkers' who rejected such outmoded lines

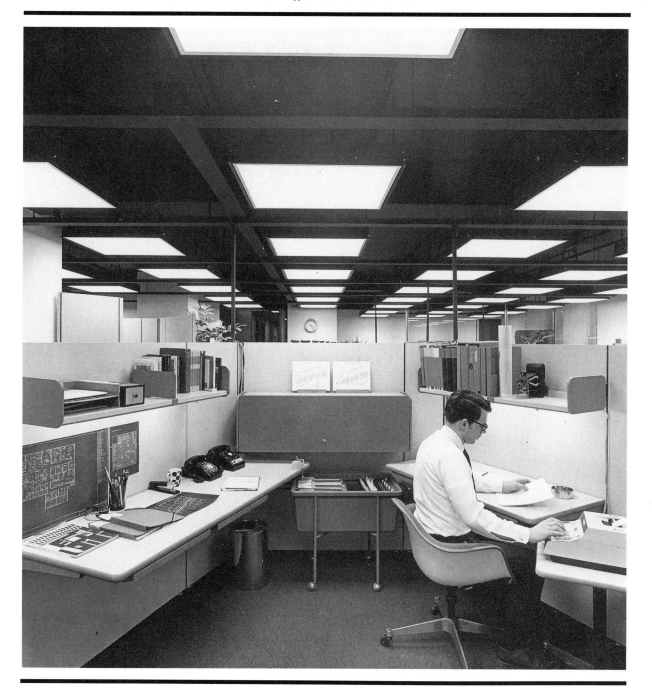

of thought. 'Action Office' was for those who were interested in *"personal productivity, who want their office to serve their mental effort rather than their egos."*

Courageous and worthy as these sentiments were, and despite its enthusiastic reception by designers and critics, the original 'Action Office' was not a commercial success. It was 'Action Office 2', introduced four years later, that was to have a profound effect on the design of office furniture.

Some of the change instituted with 'Action Office 2' made common commercial sense: the elaborate castings necessary for manufacture of the original design were replaced by inexpensive mouldings, reducing the cost of the product. But there were more fundamental changes, too. The major importance of 'Action Office 2' was its shift from a conventional, free-standing desk to 'screen-mounted' furniture. The change to a screen-mounted range was an attempt to resolve the debate between advocates of 'closed' and 'open' offices. The advantages of traditional closed, or enclosed, offices – such as privacy, a sense of ownership, quiet and concentration – were counterbalanced by the claims that open environments, particularly improved communication and egalitarianism. 'Action Office 2' was intended as a synthesis of these two views: screens enabled

territory and hierarchy to be restored to the large open floors of American corporations (and, ultimately, to the office landscapes of Europe).

Part of the genius of Propst with 'Action Office 2' was recognizing the organizational need to express and define territory. His screen-based system was justified by the need for acoustic and visual control, as well as the supposed efficiency of screen-mounted storage and worktops. At the same time, the screens brought back the possibility for establishing territoriality in the office, while preserving many of the advantageous aspects of the office landscape.

The introduction of panels, which supported work surfaces and storage units, also marked an important philosophical shift in office furniture. Before 'Action Office 2', office furniture was essentially a series of variations on standard objects within a fixed office space. 'Action Office 2', in contrast, envisioned work units which were flexible in terms of their components and which could be freely arranged in an undefined space. Instead of a hierarchy of different pieces of furniture to accommodate many different types of work, the furniture grasped office work and space as a whole.

*"The 'Action Office' concept begins with highly mobile, wall-like elements which define space, provide privacy, and physically support multi-*ple work station functions," Propst explains in The office. "As a generality, a comfortable human is not likely to be located very far from an enclosure element. It is a major definition element and organizer."*

Screens, or 'vertical standing panels' as Propst defined them, came in a variety of heights to provide a range of different enclosures. Noticeably, full-height walls were not part of the system: 'Action Office' was clearly intended for the modern office building with its clear, open spaces. The screens carry work surfaces (both desks and standing-height surfaces), racks and shelves. The systematic nature of 'Action Office' is exemplified by the ingenuity with which Herman Miller developed literally hundreds of new elements for the basic frame over the years: signs, magazine racks, telephone holders, pinboards, vertical and horizontal filing, etc. More than anything, these accessories were designed to capitalize on a major feature of the system: its capacity to handle the flood of paper which the modern office produced. 'Action Office' was the first truly storage-generated office furniture.

The strength of Propst's design can be glimpsed by the way 'Action Office' defined the terms of office furniture debate until the '80s. Although it was still possible for designer John Pile to write in 1969

that no manufacturers had paid Propst the compliment of imitation, by the late '70s scores of imitators were on the market. Screen-based systems dominated office furniture: the market share of open plan furniture increased from 3 per cent in 1967 to nearly 25 per cent in 1982. The centre of the debate about office furniture was screen-based versus freestanding. The advantages of a systems approach were largely unquestioned. As one critic wrote, '*No one sells you a desk anymore: he will try to sell you a service, a system, workstations, office products. Something very important has changed and [it isn't] just techniques of salesmanship.*"

The rapid spread of office systems in the years following the launch of 'Action Office 2' can be seen in the coverage of office furniture provided in the professional press in the early '70s. *The Architects' Journal*, a British weekly, covered what it termed a 'fair selection' of available office furniture in 1973. In a table of product information, 18 systems are detailed. While most are simple wood or metal framed pedestal desks with minimal provision of screening or storage, a number of manufacturers have clearly followed the lead of Herman Miller.

In addition to the furniture itself, what is revealing is the analysis of the situation in which furniture manufacturers of the time found themselves.

"*The differences between partitions and furniture have become increasingly blurred until we now have a situation where the furniture may be the partition and the partition part of the furniture. This means problems for the manufacturer in that he may find it hard to decide where the design specification of a new product should begin and end. He may have only a vague idea of the range of situations in which it will be used – deep and shallow spaces, varying densities of occupation and types of work being carried out and so on.*"

The problem posed by this new form of furniture, a development that evolved together with a new form of office, extended to embrace many of the architect's usual concerns. Without walls, where were light switches, power outlets and other normally fixed elements to go? At root, how much of the architecture was being subsumed in the furniture?

The radical leap of 'Action Office' made much of the rest of the late '60s office furniture seem rather pallid. Where Propst and Nelson were re-examining the fundamentals of office work, other designers were merely playing stylistic games. But some of those games produced aesthetically interesting designs. Understandably, these designs followed the preoccupations of designers in other spheres. Characteristic of this is the work

of a number of Scandinavian designers. Arne Jacobsen, the grand man of Danish architecture, designed a furniture system with the unusual name of 'Djob' for the Scandinavian Office Organisation in 1969. Aluminium frames had rounded feet, and steel joints. The typing table could be converted into a suspended filing cabinet. Tops were in wood or laminate. But the principle concern of Jacobsen and his colleague Niels Jørgen Haugesen was aesthetic: the rounded lines of the furniture complemented the lines of Jacobsen's famous '50s moulded plywood 'egg' chair.

In contrast, the '70s was a period of enormous development of office systems. With the rapidly spreading success of 'Action Office', many manufacturers in the United States and elsewhere chose to imitate and embellish the Propst design. There were a number of manufacturers and designers, though – notably in Europe – who chose to pursue different strategies.

The Swedish manufacturer Facit introduced a system orientated towards satisfying the needs of the Bürolandschaft office, called 'Facit 80'. Designed by Carl Christiansson, 'Facit 80' bears an initial resemblance to the 'Haller' system. As in 'Haller', the basic structure is of stove-enamelled steel tubing from which bookcases, storage units, mobile filing

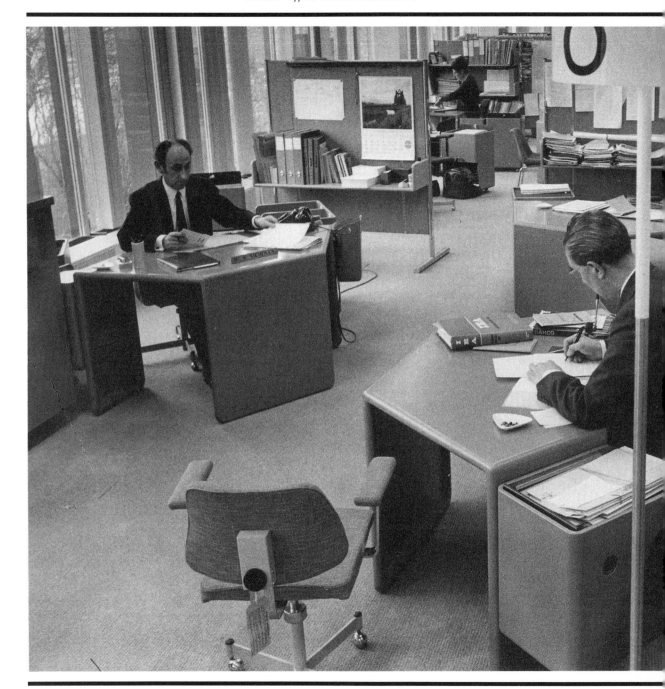

trays and worktops are hung. In addition, and betraying the Bürolandschaft orientation of the design, distinctive screens of perforated fibreboard are also hung off the same structure. To free the desk from clutter, lights and telephones are lifted off the work surface by brackets, and a side rail on the desk is used for mounting special hooks to carry handbags, mailboxes and power points. Wiring is carried up to the power points through the tubular steel legs.

Olivetti, whose 'Spazio' system in 1961 had been so aesthetically advanced, again produced one of the most innovative office systems. The 1973 'Synthesis 45' was designed by a team led by Ettore Sottsass, whose 1969 'Valentine' typewriter could almost have been a summation of '60s popular culture. 'Synthesis 45' brought much of the spirit of the 'Valentine' to the more sober world of office furniture.

'Synthesis 45' is memorable for its use of bright colours, plastics and bold and witty details: chunky knobs for chair adjustments, patterned

In contrast to the sophistication of 'Action Office', a British initiative by the Ministry of Public Works 1968 opted for curious small triangular desks, with freestanding storage elements.

umbrella stands, large, smooth drawer handles. Unfortunately, the very visual traits of the design made it easy to overlook a strong, rational logic to the system. All elements were designed to a consistent module, the provision for paper storage was high and the use of so much moulded plastic meant the manufacturing cost was relatively low.

Olivetti again proved itself as an adventurous manufacturer with the 1982 launch of the 'Icarus' system, designed by Sottsass with Michele de Lucchi. As with 'Synthesis 45', 'Icarus' is not memorable for any

Right: Olivetti's 1973 'Synthesis 45' was perhaps the first mass-production attempt to introduce humour and bright colours to the office. The extensive use of moulded plastic kept manufacturing costs low.

Below: Certainly the most visually distinctive of the systems contemporary with 'Action Office' was the Swedish 'Facit 80'. With a Bürolandschaft lineage, the furniture is lightweight, and distinguished by the perforated fibreboard.

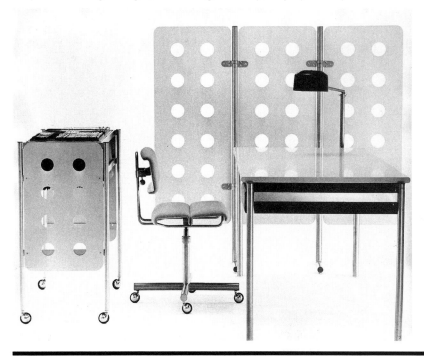

revolution in form. But it did continue the line established by the earlier project in humanizing the office, even, perhaps, bringing a little humour into the working environment. Again, the colours were important: greys, yellows and aquamarines offered a more subdued palette. Other details showed a softening of approach, notably the round leg, with its wide base that tended to make the desk look more like a dining table.

By 1982, the approach Olivetti had initiated with 'Synthesis 45' had many adherents, particularly in Italy. Perhaps the best of the Italian systems was 'Il Pianeta Ufficio', designed by Mario Bellini for Marcatré. Bellini's design had one important new feature that has since been widely copied: a rounded conference end to the standard carrel-like desk. The conference end was recognition of the increasing informality of office work. Conferences not only happened in conference rooms, but should be encouraged to develop spontaneously around a desk. The marketing of the Bellini range also emphasized its softened approach to the office: the system was portrayed floating, dreamlike, in the clouds.

American systems tended much more strongly towards corporate conformity. 'Action Office 2' had determined the American standard, and although the market lead was to fall

to other companies, such as Steelcase (which had built Frank Lloyd Wright's furniture for the Johnson Wax building), little of the inventiveness that was beginning to spread through Europe was evident in the United States. Typical of the American systems, and one of the most successful, was Knoll's 'Stephens' range. 'Stephens' was basically a box-shaped design, with desks enclosed on three sides by high solid panels which support shelving and lighting. The thick wood-veneered elements suggest solidity and tradition, in a way similar to those corporations which choose to have wood panelling in their steel-framed office buildings.

George Nelson's thinking on office furniture did not end with his work on the original 'Action Office'. In the 1970s he returned to the problems he had first analysed in the '50s which were to be such an important part of his work for four decades. Nelson started his study of the office from simple observation of the way people work and how they feel about their role in large organizations. When Nelson's practice was commissioned in 1973 to design the interiors for the Aid Association to Lutherans (AAL), Appleton, Wisconsin, they determined that no existing system was suitable for the project.

Nelson has described part of the lengthy process he followed in the project.

"AAL gave us a test area, an existing department in their old building. We got Luxo lamps and clamped them to the desks. You wouldn't believe the excitement this caused. So I checked and found that nobody in Appleton, Wisconsin, had ever seen a Luxo lamp. So I went back and talked to these people, and what I gradually discovered was that all these people felt quite helpless. They don't make decisions, they just stamp here and sign there. You give them a Luxo and they can adjust it to light whatever they want. This gradually developed into the notion that people's happiness in a workspace related directly to the degree of control they have over their environment."

With the work at AAL as a basis, in 1977 Nelson launched his new system, named 'Workspaces', which attempted to return power to the users. An adjustable lamp and blind, book holder, waste bin, personal planter, and plug-in sign were all part of the system. Ahead of his time, too, Nelson adopted the notion that has been popularized as High Tech, High Touch. The insides of the workstation, where users came into direct, regular contact with the furniture, had soft surfaces, while the exterior was hard and shiny. The junction between the hard exterior and soft interior was a connector strip into which all accessories and panels plug-

ged. A one-inch gap between panels and worksurfaces was maintained to allow visual contact.

All elements of 'Workspaces' were assembled on a bellows-like base, which provided visual continuity between different items. The detachable bases carried wiring, and also allowed a furniture layout to be organized and approved before the heavy work of building up panels and desks was carried out. The most interesting item in Nelson's system, however, was a freestanding conference 'room'. A circle of panels stands round a table with a 3 m diameter

The box-shaped Knoll 'Stephens' range played on the still-prevalent desire for 'traditional' wood in most organizations.

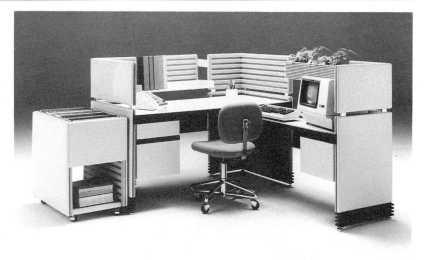

Above: Although it had little of the influence of his earlier work, George Nelson's 'Workspaces', for Storwal Incorporated, displayed many of the design details that so enriched his projects. Inside surfaces, where users came into constant contact with the furniture, were soft, while exteriors were hard for both durability and privacy.

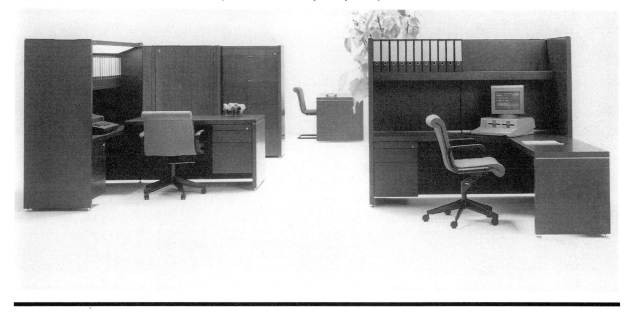

Left: 'Icarus' continued Olivetti's theme of humanizing the office.

Bottom left: Marcatré's 'Il Pianeta Ufficio' recognized the increasing informality of the office – the rounded conference end allowed discussions to take place.

Right: Steelcase's panel-based systems of the '70s are characterized by their stolid solidity.

Bottom right: Sunar's 'Race', designed by Douglas Ball in 1979.

Below: Herman Miller's 'Burdick Group', purveyed a High-Tech image of the office for executives who could afford the staggering expense of the furniture.

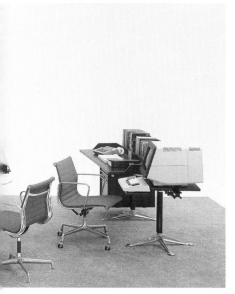

nylon-covered umbrella above. The umbrella serves as a 'ceiling' for the conference room, and lights fixed to the umbrella pole bounce light against the underside of the umbrella. The enclosure also gave a significant degree of sound insulation, making the use of the conference room in open plan floors practical.

Some American designers recognized relatively early the increasing problem of servicing the modern office. Douglas Ball's 1979 'Race' system, for Sunar, provided an early solution for what came to be called cable management. The central idea of 'Race' is a desk-height beam that carries all necessary electrical (and as technology developed, data) cabling, and also provides support for the cantilevered worksurfaces. The beam also provides a base for building a frame of tile-like partitions, shelving and storage units.

Herman Miller developed a beam-based system, too, with designer Bruce Burdick. From the start though, the 'Burdick Group', with its immaculately detailed cast aluminium beam and accessories, was intended as a system aimed only at executives who could afford such an expensive adoration of technology. Perhaps blinded by the continuing success of 'Action Office 2', Miller failed to spot the usefulness of the beam at a point where everyone concerned with the office was begin-

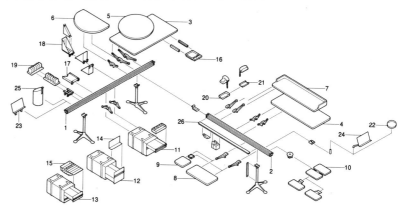

Above: 'Burdick Group' was a kit-of-parts, with all of the elements suspended from or mounted on the beam.

Below: Olivetti's 'TC800 intelligent terminal system', designed by Ettore Sottsass and George Sowden in 1974. The machinery is the furniture; ten years previously it would have been the room.

ning to worry about the problem of how to get wires to the desk.

Office furniture design in the first three-quarters of the century concentrated primarily on working methods and, only as an over-riding problem, handling paper storage. With the 19th-century invention of the typewriter, followed by various techniques for copying documents, paper threatened to swamp the office in ever increasing quantities. Furniture – whether filing cabinets, desk drawers, or pigeonholes – had to be designed to cope with it.

New computer technology, allowing for data storage on tape or disk, changed the terms for furniture designers. The early use of computers in organizations was in large, data processing departments, with bulky machines that could easily fill large rooms. But as technology advanced, computer hardware decreased in size.

Through the '70s, furniture for computers was a meaningless concept: as Sottsass and Bellini's elegant work for Olivetti shows, the computer terminal itself was its own furniture. But with the development of the desktop microcomputer by Apple in the late '70s, computers now began to appear on office desks. Unlike most previous office technology, the computer produced particular problems: a proliferation of wires and heat, and a need to carefully control light and static. For furniture

designers, the wires proved the principle problem. There could easily be a need for a 'clean' power supply (not contaminated by electrical interference) and connections to a printer, to a separate disc drive and to a data network. And, of course, the existing wires on a desk—telephone and light—were still necessary.

Without some means of controlling these wires, fire hazards, maintaining data connections, and just unsightly mess in the office resulted. So from concentrating on paper stor-

The ultimate clash of furniture, technology and people: workstations house numerous visual display units, telephone switchboards, computers and intercoms.

age, office furniture designers turned their attention to 'wire management'. While the 'Race System' showed an early recognition of the problem, most '70s' and even early '80s' designs had to be crudely modified to cope with the problem.

The problem of wire or cable management was twofold: bringing wires from the floor, office perimeter or ceiling trunking to the worksurface, and then distributing the wires horizontally. Most manufacturers opted for vertical channels in desk legs or panels to solve the first, while a variety of trays, channels, 'tidies' and dumps were devised for the second. With the increasing importance of wire management, it was the next generation of office furniture that was to see the largest effects.

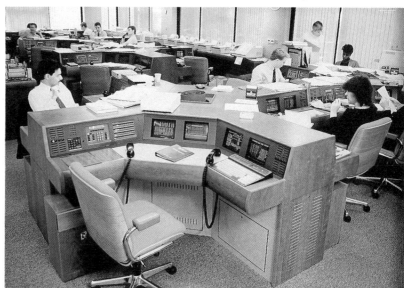

THE late '70s was a period of enormous developments in the office chair. Many of the problems of chair design had been recognized in the 19th century: back support, correct height of seat and back, etc. And, in many ways, the typical typist's chair, which had endured almost without variation since the turn of the century, was a good resolution of the problem.

Right: Ambasz and Piretti's 'Vertebra' chair was particularly successful in displaying its 'dynamism' through the bellows-like rubber sheaths.

The 'Vitramat' was the first office chair that recognized the user's usual failure to adjust a chair 'properly'.

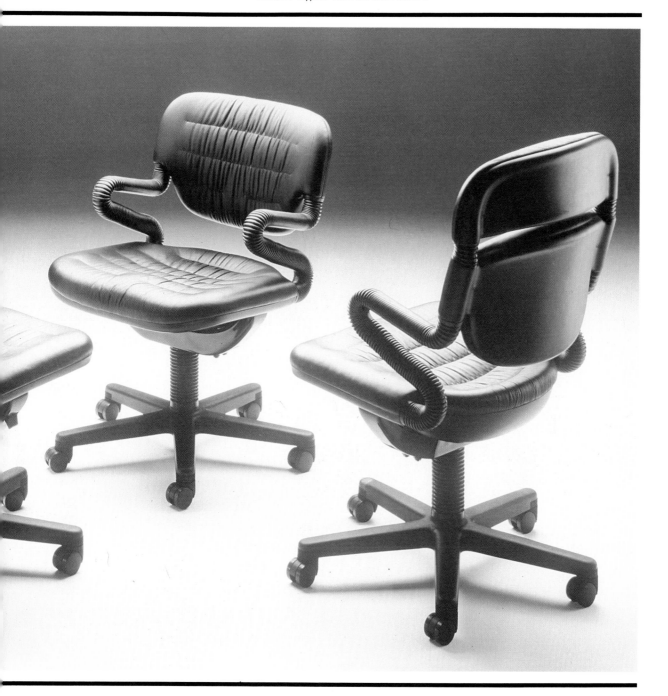

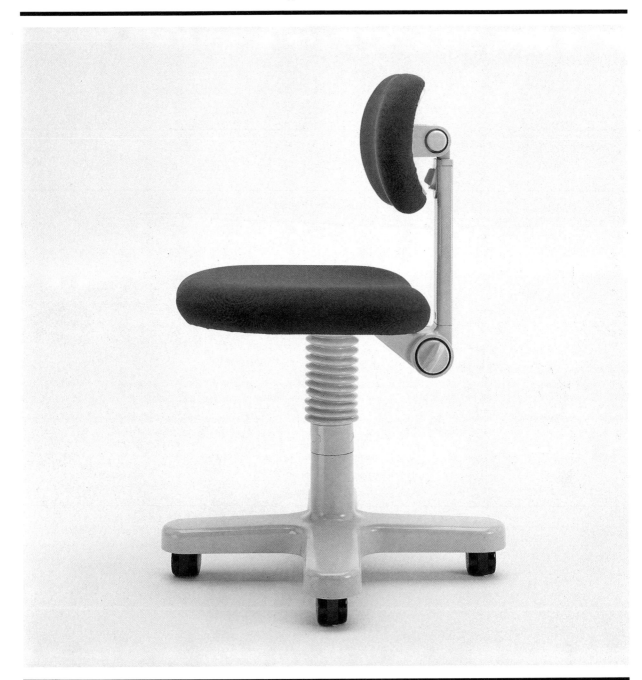

The problem with the traditional approach to chair design, however, was not in the chairs themselves, but in their users. A typical typist's chair, or even a beautiful variation like Ettore Sottsass 'Z9/r' for Olivetti, relied on the user to determine the correct seat height, back height and back angle adjustments. But most users tended to make the wrong adjustments (in terms of proper support), and to never take advantage of chairs' much-vaunted abilities for readjustment. Once a screw was tightened, or a knob turned, that was pretty much that.

Perhaps the first of the new wave of 'scientific' or 'ergonomic' chairs was the 'Vitramat', designed for the Swiss manufacturer Vitra by Wolfgang Müller-Deisig in 1976. The most innovative aspect of the 'Vitramat' chair was the way it took advantage of the different densities of injected foam. The chair's three main parts, seat, lumbar support and back, all had different firmnesses to suit the varying needs of different parts of the body. 'Vitramat' was also designed so that the user had no need to adjust the chair. Instead of relying on the user to

Left: For all of its whimsy, manufacturing sophistication and design appeal, Olivetti's 'Z9/r' chair was little different from typists' chairs of the turn-of-the-century.

Many office chairs had elegant forms, but without the important 'dynamic' action of 'Vertebra' and 'FS'. Hille's 'Supporto', designed by Fred Scott, used a robust steel frame in contrast to the common plastics.

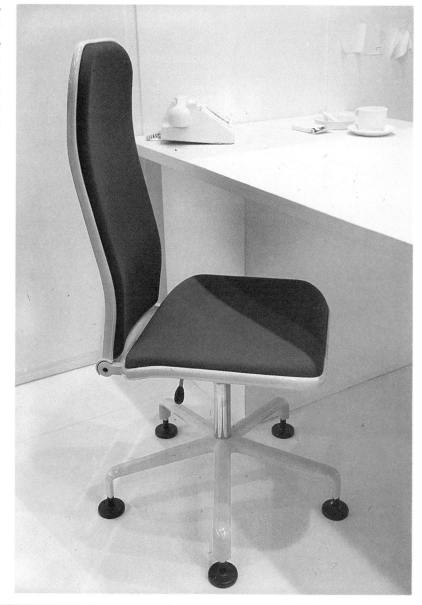

set the tilt of the chair, Muller-Deisig's design was 'dynamic': the back moved with the user to provide constant support.

Three years later the same notion was developed further with the 'Vertebra' chair, design by Emilio Ambasz and Giancarlo Piretti for Castelli. The seat and back shifted with the user, so ensuring that the chair was always providing proper support. The Ambasz and Piretti design is particularly successful in visibly displaying its 'dynamism'. The moving parts are housed in bellows-like rubber sheaths, signalling the non-static nature of the design.

Despite the significant ergonomic advance of 'Vertebra', there were problems in the way it linked seat and back. Some users complained that the chair felt as though it was trying to take their trousers off. The key to this problem was found by German designers Franck and Sauer, with their 1979 'FS' chair for Wilkhahn. Instead of being dynamic around a single pivot, 'FS' pivots around two points, one towards the front of the seat, the other just forward of the point where the back joins the seat.

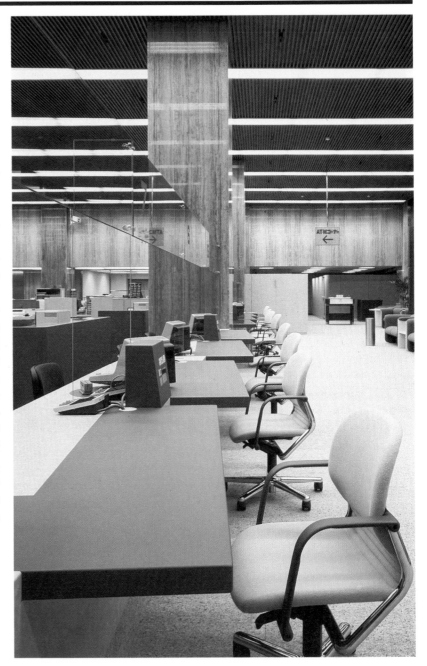

The Wilkhahn 'FS', designed by Franck and Sauer in 1979, pivots around two points, preventing the feeling that the seat is sliding out from underneath the user.

THE REACTION AGAINST SYSTEMS

SYSTEM orientated thinking made certain assumptions about the needs of organizations. The furniture takes for granted that the office building will be capable of being arranged around large open plans. (This may explain some of Britain's tardiness in adopting modern office layouts. In contrast to the United States, Germany and even France, Britain had a relatively small stock of modern office buildings until the late '60s.) More importantly, systems furniture assumes that an entire office should look neat and uniform; that there is a consistent corporate image to be reflected. And crucially, systems assume careful control of the workplace. As one designer has observed, *"You can only keep your office as tidy as a battleship if you have as much*

Hertzberger's Centraal Beheer is planned around a grid of concrete block 'work islands', each providing for groups of 16 workers.

power as an admiral." For all their much-vaunted flexibility, the repetitive nature of hundreds, or in many American offices, thousands, of identical combinations meant that office systems soon became synonymous with stereotyped environments – just what Propst and Nelson had set out to destroy with 'Action Office'. The '70s marked the beginning of a reaction against glass box office architecture; it also saw the first attempts to find alternatives to systems furniture for large offices.

Not surprisingly, the most significant reaction came not from the United States, where the ethos of corporate architecture and its equivalent corporate furniture was so strong, but from Europe. Many of the ideas that had fuelled the spread of Bürolandschaft in the late '50s returned to provide new notions for the office. Particularly in the years following the upheavals of 1968, the emphasis in Germany, Scandinavia and Holland turned towards reasserting democracy and individual control in the office environment.

The seminal office building of the early '70s is Hermann Hertzberger's Centraal Beheer, Apeldoorn. Hertzberger's building is like an Italian hill town with identical elements all piled one on top of the other. Yet the rigidity of Hertzberger's grid of concrete block 'work islands', each providing for groups of sixteen workers, provides a framework within which individuals are free to decorate (or not to decorate) his or her area in whatever fashion is desired.

Hertzberger's solution is preeminently an architectural one. Within the strong framework of the building, the importance of the furniture choice was reduced: simple tables and desks are used, but are hardly noticeable in the rich layering of the interior. Centraal Beheer offered workers complete freedom to personalize their workspace without risking organization-disrupting visual chaos, for the building provides an over-riding order. And the profusion of at times eccentric, personalized touches (animals, espresso-machines, primitive masks around ventilation grilles), so in contrast to the forlorn displays of family snapshots, calendars and odd potted plants found in most 'personalized' offices.

Centraal Beheer marks a culmination of one type of thinking about the office, and there are many designs in Germany and Holland which share some of the characteristics of the scheme. The acceptance of a more democratic notion of the workplace can be seen at the most basic level in the architecture of the typical German office building: there is far less reliance on the strict right-angled grid imposed by the demands of the wholly commercially orientated property developer. Instead more complicated polygonal patterns are common, allowing for more complex (but expensive in construction) division of the workplace.

Typical of this sort of building is GEW, Cologne, by Kraemer Sieverts & Partner, 1980. GEW is a honeycomb of 200 sq m octagonal elements, creating relatively small, articulated Bürolandschaft spaces within the building. Hence team spaces are formed, with loosely arranged furniture and low screens to give some privacy and sound insulation. These team spaces (*Gruppenräume*) are for working groups of 10 to 15 people, and such is the design that it would be difficult to break up this team concept. Central glass-roofed atria give a focus to each work area, with a red spiral staircase offering easy communication between floors.

GEW is especially innovative in its approach towards providing individual control of the office environment. Air supply is from ducting below the false floor, through outlets which are integrated with removable and carpeted panels. But there is a further air supply – for the micro-

Within the strong framework of Centraal Beheer at times eccentric, personal touches are prevalent.

climate of an individual's desk – that is connected through the furniture. These 'local air conditioning units' resemble the air nozzles on a passenger airplane, and are adjusted in exactly the same way.

Some alternatives were being explored in the United States as well, usually in prestigious corporate headquarters. Certainly the most intriguing example was the new headquarters for Union Carbide on a greenfield site in Connecticut. Union Carbide's 1957-60 Park Avenue headquarters by Skidmore Owings and Merrill had virtually defined the office building of that generation. A gleaming steel and glass curtain wall structure, the interior was highly regimented with a hierarchy of Byzantine complexity expressed through the size of office and accessories.

Roche Dinkeloo, the architects for the new building, carried out a detailed survey of staff attitudes towards the existing environment. The results confirmed widespread dissatisfaction with the open plan offices and resentment at all levels of the organization of the visible hierarchies. The proposal for the new offices was a complete rejection of the old. In the massive building, all personnel would have a cellular office of 3.75 sq m, no matter what position they held in the company. All 2,300 offices have windows, and all personnel were given an identical choice of

their own furniture.

For the furniture, Roche Dinkeloo prepared 30 model designs, and staff were shown mock-ups and asked to pick their preference. Quality was consistent in the options, but layout, colour, accessories and furniture style (defined by the architects as traditional, transitional, contemporary and modern) varied. The furniture tends to be domestic in feel, rejecting both a systems approach, just as the building seems to reject overt systematization of the organization. The experiment was brave, but old hierarchies die hard: in the years since the occupation of the building, executives have begun claiming adjacent offices to increase the size of their personal empires.

Ironically, the first large-scale assault on the dominance of office systems came from the originators of the field, Herman Miller. The development of 'Action Office' in the '60s had ensured Miller years of sustained growth. But by the late '70s, many observers in the design community felt the company was resting on its laurels and not responding to the advances and new thinking of one-time unimportant competitors. In the early '80s, following some shifts in its shareholdings, control of Miller returned to the DePree family, in the person of Max DePree, son of Hugh, who had 'discovered' Robert Propst.

Seeking revitalization, Max DePree turned to Bill Stumpf, a

Right: Bill Stumpf's 1985 'Equa' chair looks a bit like a large mouth about to gobble up the user.

Below: In the same year as 'Equa', Mario Bellini designed a chair range for Vitra called 'Figura'. It emphasized the soft, tactile aspects of furniture: Bellini labelled his approach High Tech-High Touch.

Below left: 'Ethospace' is based on tile-like panels that snap into frames, allowing workers, in theory, to easily change their own workplace.

designer who had worked with Propst on earlier Miller projects. Stumpf's first product for the renaissance of Miller was the 'Equa' chair, which, in the manner of Wilkhahn's 'FS' and Castelli's 'Vertebra', was 'dynamic'. Characteristically for Stumpf, 'Equa' also seemed a product with a slight sense of humour: the chair almost looks like a large mouth about to gobble up the user.

It was Stumpf's second development, however, that truly seemed to break the mould created by Miller nearly 20 years before. 'Ethospace', launched in 1985, might be termed the first anti-system system.

Stumpf had told Miller, when first approached on the project, that he would not design an office furniture system. He saw the importance of moving from what he terms a 'manager-centred' environment to a 'user-centred' one. Although this had been the original intent of Propst with 'Action Office', it had been impossible to foresee the extent to which the panel-based system and its relative complexity forced companies to take assembly and configuration decisions out of the user's hands.

The central element of 'Etho-

Bellini's 'Figura' chair is the first 'undressable' office chair, allowing the user to choose and change fabrics and colours.

space' is the tile-like panels that snap into frames. The simplicity of the tiles—no tools are needed—means that individual workers should be able to affect change at their own workplace (though this will still depend on a management willing to give workers this right). The tiles concept owes a little to Douglas Ball's 'Race', but 'Ethospace' takes it much further. Tiled frames build up to become walls, with a visible thickness, allowing the semblance of a room to be created within an open plan building.

While 'Ethospace' is an attempt to bring back traditional virtues to the office—enclosure and individual character—some designers and manufacturers have taken a different course recently. Tecno, one of the leading Italian furniture manufacturers, commissioned Foster Associates to develop a new range of office furniture for them in 1985. Foster Associates was a British architectural practice famous for its High-Tech buildings, most notably the Hong Kong and Shanghai Bank headquarters in Hong Kong and the Sainsbury Centre for the Visual Arts in Norwich. So when they turned their attention to the office, it is not surprising that a highly technocratic solution resulted.

In contrast to the analysis that produced 'Ethospace' and other recent office systems, Foster's range

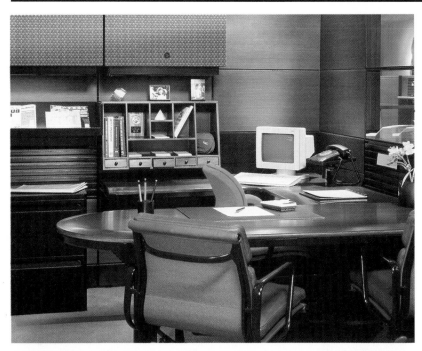

The marketing of 'Ethospace' is significant in the way it emphasizes human qualities through unusual fabrics and the bric-a-brac of a real person's office.

took as its premise that space was at a premium in the modern office. So the design eschews space-gobbling panels or separate storage units. Everything is based on the central element – the table. Storage, lighting and all other necessary elements are raised above the worktop.

According to the designers, it was decided early in the development of 'Nomos', as the range is called, that *"it was inappropriate to try to do everything with one solution"*. 'Nomos' is not, in their words, a 'Swiss Army knife' with numerous specialized accessories gathered into a single package. Instead, the designers opted for a relatively open design that provides a basic framework for office users rather than a fixed, carefully structured environment. 'It's an

Left: Foster's 'Nomos' relies on the sleek image of technology and structural gymnastics.

Right: The modern ideal of a kit-of-parts is at the heart of 'Nomos'. The designers call 'Nomos' an inventory, rather than a system.

inventory, not a system', explain the designers.

'Nomos' seems to turn back in many ways to the work of George Nelson on the original 'Action Office'. A structural I-beam is the basis of the design, with table legs, supports for shelving above the worktop, and worktop supports, plugged into the beam. But for all the magnificent finish of the furniture, 'Nomos' is basically a table system, unlike most of the developments since the '60s. One of the truly innovative elements of the design is the method for cable management. Rather than hiding the cables in ducts or trays, Foster chose to celebrate the demands of information technology with a spine of plastic vertebrae: wires and cables are threaded through the vertebrae without the need to remove plugs. This spine then provides a sinuous counterpoint to the rigidly ordered perfection of the rest of the furniture.

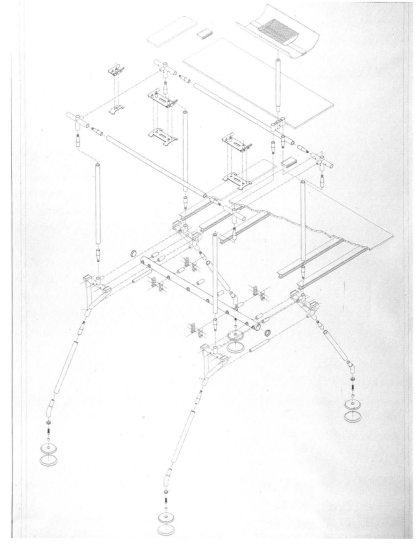

Another approach, placed somewhere between 'Nomos' and 'Ethospace', is illustrated by Richard Sapper's 'From Nine to Five', launched by Castelli in October 1986. 'From Nine to Five' is intended to satisfy the most demanding requirements of the modern office, and boasts a capacious beam to handle large quantities of cables. But more crucial in the thinking behind the system was Sapper's determination to humanize the office: so no screens are placed in front of the work surface, avoiding the isolation experienced in many systems. Instead, Sapper plans for screens to be behind workers, ending the notion that colleagues (or, worse, bosses) can creep up behind and stab one in the back. The name, too, avoids the aggrandisement of the Greek-derived 'Ethospace' and 'Nomos', opting for the directness of a title of a film starring Dolly Parton and Jane Fonda.

CONCLUSION

TWO distinct strands of thought can be seen in the century of office furniture design. One, probably dominant and certainly the most visible, has been technologically led. In response to new materials — such as tubular steel and laminated wood — or new technology — such as the typewriter, the telephone and desktop computer — designers have devised new furniture. The forays of Modern Movement designers in the '20s and '30s, much of the work of Eames, and the responses in the last ten years to the problem of wire management can be seen in this light.

Few of these designs have been solely the result of technological change. Every design needs a client, and in the case of office furniture the user organizations — businesses, governments and institutions — have in most cases provided a motivation for exploiting a technology (in the case of new materials) or a commercial justification for using new developments (in the case of office equipment). Designers, and the manufacturers who use them, have responded to these needs.

An alternative strand has been of increasing importance. Instead of technology as a starting point, a number of designs in the last century have started from an analysis of organizations themselves, and of the people that work within them. In some ways, this was the attitude of the Taylorists, who were trying to provide a more efficient working environment. And in the major shift of the late '50s and early '60s, the development of Bürolandschaft, working methods, specifically inter-nal communication, were the spur.

For many, however, Bürolandschaft had an additional agenda: the democratization of the workplace. The simple, easily movable furniture designed for the landscaped office was an attempt to be solely functional, without regard for visible marks of status. The seminal 'Action Office' sprung from similar motivations, with the additional realization that the workplace needed a sense of individual territory.

The altruistic genesis of Bürolandschaft and, later, of 'Action Office' and its many clones, was soon overtaken by the need for believable commercial benefit. So the original aims of providing what in sum was a more humane workplace were replaced with analyses of efficient use of office space. Henry Ford's attitude

towards his factory space — crowding leads to a loss of time, but an excess of space leads to a loss of money — was revived and dressed up by sophisticated marketing campaigns to convince companies that only by changing their furniture could they compete with, and best, their rivals.

Fortunately, the attempts to inject humanity into the workplace were not entirely subsumed. With the increasing sophistication of workers, particularly in those fields where well-qualified staff are in short supply, such as finance or high technology, the working environment has become a more important consideration for companies. The need to create workplaces that nurture good work has, in some instances, become recognized as a realistic, pragmatic organizational goal.

As an exercise in office planning and architecture Centraal Beheer symbolizes this shift. But more crucially, for it has the power to affect many more people, have been the moves by furniture manufacturers to satisfy this new-found market. Herman Miller's 'Ethospace', with its intention of forming individually controllable spaces within the office, and Castelli's 'Nine to Five', with its stress on privacy and personal possession of the workplace, are the two most prominent examples.

Perhaps these new designs may be

the initial signs that the balance of office design in the final years of the 20th century may swing towards satisfying the workers, rather than more abstract notions of faceless companies and organizations. Ralph Erskine, the Swedish architect best known for his human-scale, community-inspired housing, best caught this new mood in his 1969 vision of the office, 'The own place in the community landscape'.

Erskine saw the problem of office furniture as one more of questions than answers, to be solved in each case differently.

"An Office Landscape: an organized environment for 'togetherness'? (too

Above and overleaf: Despite all of the changes in the office and its furniture over the last century, confusion now reigns over an appropriate image for the office: can it remain traditional with the advent of new technology (overleaf, top left); should it try to regain the character and dignity of architectural elements and spaces (overleaf, top right); can the idiosyncracies of users preserve a clean, well-ordered, technology led environment (overleaf, main picture); is something altogether more humble and improvised appropriate (above) or are entirely new forms called for (overleaf, bottom right)?

much together? too organised?) Rational?...Control? Democracy? Democracy without individuals? Where is the individualist? The exccentric [sic]? The maladjusted? The noisy? Miss Gustavsson? Mr Svensson?...Could we let the 'private' people be private, the sociable be chummy, the messy be messy and the tidy have a tidy room?"

The loose-fit furniture that Erskine was striving for is conceptually close to the most recent ideas from leading, thinking manufacturers.

If the office furniture that will evolve in the next century of design development can concentrate on solving the problems of the workers, who are all different, all individuals, then the office is certain to become a far better place. Or, as Erskine modestly says, "*Neither buildings nor furniture solve social or psychological problems, but hopefully they can help.*"

Ralph Erskine's humane vision of the problems and potential of office furniture: 'The own place in the community landscape'

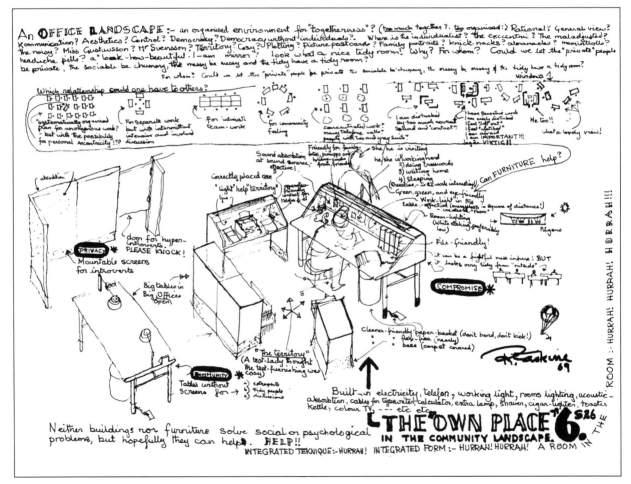

BIBLIOGRAPHY

ANONYMOUS 'Symbols and servants', *The Architectural Review*, May 1963, pp 353–362.

BELLINI, M. (ed) *Album 2: office project*. Electa, Milan, 1983.

BRANZI, A. and De LUCCHI, M. (eds) *Il design italiano degli anni '50* IGIS, Milan, 1981.

CAMPBELL-COLE, B. and BENTON, T. (eds) *Tubular steel furniture* The Art Book Company, London, 1979.

CAPLAN, R. *The design of Herman Miller* Whitney Library of Design, New York, 1976.

CAVE, C. 'Three older office buildings', *The Architects' Journal*, March 1975, pp627–632.

COWAN, P. et.al. *The office. A facet of urban growth* Heinemann Educational Books Ltd, London, 1969.

DAL CO, F. *Kevin Roche* The Architectural Press, London, 1986.

de SOLA POOL, I. (ed) *The social impact of the telephone* The MIT Press, Cambridge, 1977.

DREXLER, A. *Charles Eames. Furniture from the design collection* Museum of Modern Art, New York, 1973.

DUFFY, F. *Office landscaping. A new approach to office planning* Anbar Publications Ltd, London, 1969.

DUFFY, F. 'Bürolandschaft '58–'78', *The Architectural Review*, January 1979, pp 54–58.

DUFFY, F. 'Office furniture', *The Architectural Review*, June 1979, pp 366–370.

DUFFY, F. 'Offices, an escape from banality', *The Architectural Review*, November 1983, pp 31–35.

DUFFY, F., CAVE, C. and WORTHINGTON, J. (eds) *Planning office space* The Architectural Press, London, 1976.

FORTY, A. 'Objects of desire' , *Design and society 1750–1980* Thames and Hudson, London, 1986.

FRIEDMAN, M. (ed) 'A serious chair', *Design Quarterly* (No. 126), 1984.

GIEDION, S. *Mechanisation takes command* Oxford University Press, Oxford, 1948.

HASSENPFLUG, G. *Stahlmöbel* Verlag Stahleisen, Düsseldorf, 1960.

KLEIN, J.G. *The office book* Frederick Muller Limited, London, 1982.

KREMERSKOTHEN, J. (ed) *Moderne Klassiker: Möbel die Geschichte machen* Verlag Gruner + Jahr, Hamburg, n.d.

LEFFINGWELL, W. H. *Office management: principles and practices*. A.W. Shaw Co, Chicago, 1925.

LIPMAN, J. *Frank Lloyd Wright and the Johnson Wax buildings* The Architectural Press, London, 1986.

LYALL, S. *Hille: 75 years of British furniture* Elron Press, London, 1981.

MANG, K. *History of modern furniture* Academy Editions, London, 1978.

NELSON, G. (ed) *Chairs* Whitney

Publications, New York, 1953.

NELSON, G. 'The office revolution' in *George Nelson on design* The Architectural Press, London, 1979, pp 152–159.

PEVSNER, N. *A history of building types* Thames and Hudson, London, 1976.

PROBST, R. *The office. A facility based on change* Herman Miller, Zeeland, 1968.

SEMBACH, K. (ed) *Contemporary furniture* The Design Council, London, 1982.

SHARP, D., BENTON, T. and CAMPBELL-COLE, B. *Pel and tubular steel furniture of the thirties* The Architectural Association, London, 1977.

SIEVERTS, E. *Bürohaus- und Verwaltungsbau* Verlag W. Kohlhammer, Stuttgart, 1980.

SPAETH, D. *Mies van der Rohe* The Architectural Press, London, 1985.

WANKUM, A. *Layout planning in the landscaped office* Anbar Publications Ltd, London, 1969.

WILK, C. *Thonet: 150 years of furniture* Barron's, Woodbury, New York, 1980.

ACKNOWLEDGEMENTS

T = top; B = bottom; R = right; L = left

The author and publishers would like to thank the following for their kind permission to reproduce the photographs on the pages listed:
Architectural Press: 5, 7, 9, 13(R), 15, 16, 22–23, 24, 32, 37, 38, 41, 44(T,B), 45, 48(B), 57 (T,B), 58, 59, 60, 62, 63, 64, 67(T,B), 68(L,R), 72, 77, 80–81, 82, 83, 88(T), 97, 105, 107(T), 108; Bank of England: 6; Callaghan PR: 106(TL); Castelli Ltd: 1; Martin Charles: 106–107; Design Council: 34(T), 56, 69, 93; John Donat: 67(B); Ralph Erskine: 108; Germanisches Nationalmuseum: 34(B) Glasgow School of Art: 19; Hertzberger: 95; Hille International Ltd: 68(L); Interspace Ltd: 91; Johnson Wax Inc: 40; Johan van der Keuleen: 97; Knoll International: 53, 56, 73, 85(B); Magpie furniture: 63; W.F. Mansell: 5; Marcatré Ltd: 86(B), 107(B); Felix Marchilhac: 30(T,B); Midland Bank Plc: 89; Herman Miller Ltd: 46, 50, 76, 86–87, 98(BL), 99, 102(T); Ministry of Works, Crown ©: 57(T,B); MIT Press, London: 10; Olivetti Synthesis SpA: 66(T), 86(T), 88(B), 92; Osterreichische Postsparkasse: 26, 27; Race Furniture: 87(B); Rassegna: 29(T,B); Scott Howard Furniture Ltd: 55, 70; Sotheby's: 34–35; Steelcase Strafor (UK) Ltd: 14, 42, 87(T); Ezra Stoller, © ESTO: 44(T), 45, 48(B); Storwal International Inc: 85(T); Tecno Ltd: 102(B), 103; Gebruder Thönet GmbH: 25, 31, 33, 35; Universe Books: 71; Trustees of the Victoria and Albert Museum: 18, 21, 36(T,B); Vitra Ltd: 50, 51, 90, 98(BR); Collection Walker Art Center, Minneapolis (Gift of the Walker Foundation, Gilbert M. Walker Fund, 1948): 43; Wilkhahn: 94

INDEX